SECRET SWINDON

Angela Atkinson

AMBERLEY

I dedicate this book to Professor Robin Jarvis of the English Department at the University of the West of England. His encouraging words sparked a classic light-bulb moment, one that inspired me to take Moving Words, a travel writing module. Had I not followed that particular course of study, it's much less likely that my Born Again Swindonian blog would have been well ... born. Were it not for the blog, there would be no 'Secret Swindon' for sure.

First published 2018

Amberley Publishing
The Hill, Stroud
Gloucestershire, GL5 4EP

www.amberley-books.com

Copyright © Angela Atkinson, 2018

The right of Angela Atkinson to be identified as the Author of this work has been asserted in accordance with the Copyrights, Designs and Patents Act 1988.

ISBN 978 1 4456 8338 6 (print)
ISBN 978 1 4456 8339 3 (ebook)

All rights reserved. No part of this book may be reprinted or reproduced or utilised in any form or by any electronic, mechanical or other means, now known or hereafter invented, including photocopying and recording, or in any information storage or retrieval system, without the permission in writing from the Publishers.

British Library Cataloguing in Publication Data.
A catalogue record for this book is available from the British Library.

Origination by Amberley Publishing.
Printed in Great Britain.

Contents

Foreword

Call me crazy if you like, but I believe there is a secret ingredient to my home town, which I like to call 'the Spirit of Swindon'.

There are plenty of people who think it is clever to point out Swindon's apparent faults, as if other urban conurbations are perfect and the rest of us are blind, and sadly (for them and us) they struggle to see the spirit that lies beneath.

However, happily (for them and us) there are also others who are on exactly the right wavelength to lock into it. Angela Atkinson is one of these people, and she is always on a mission to discover the sources of that elusive spirit and uncover its secrets.

The Spirit of Swindon manifests itself in many ways, from the genius of the railwaymen at the hub of the greatest railway the world has ever seen to the genius that is the Magic Roundabout, and everything in-between, and you will find that much of it is captured in the pages of this book.

So think of it as a report on Angela's findings, but also a manual. It's an indispensable road map for anybody trying to locate and navigate through the Spirit of Swindon, and if you want to find the right frequency and stay tuned to it, I can think of no better person than Angela to twiddle the knobs for you.

Graham Carter, editor of *Swindon Heritage* magazine

Introduction

What is now Swindon's Old Town and once was Old Swindon began life as an Anglo-Saxon defensible settlement atop a limestone hill. The Domesday Book records this settlement as both Suindune and Suindone – thought to derive from the Old English words 'swine' and 'dun', meaning 'pig hill'. There is though an alternative explanation for how this ancient village got its name. Richard Jefferies (who you shall meet fully in chapter two) wrote in his 1875-essay 'The Story of Swindon' of a dim legend speaking of the great Sweyn halting with his army on this hill. From that day forth the hill became Sweyne's dune, and from that to Swindon. There are two operative words in all that: one is legend and the other is 'dim'.

This early version of Swindon became a small market town of lesser importance than nearby Highworth and other surrounding villages. A sculpture of a ram marks the site where the livestock market took place. This is one of many pieces of public art that punctuate the town and of which there's more in the pages that follow. I'm puzzled that a town that is, in essence, named pig hill doesn't count among its extensive public art collection a bronze pig. Why there's a ram but no ham I cannot say. A preference for the Sweyn legend rather than acceptance of prosaic fact? Ewe tell me. No one knows for sure.

As a sleepy, pig-farming market town Old Swindon would likely have stayed were it not for the winds of change that blew its way via the Industrial Revolution. The subsequent acceleration in Swindon's growth began with the 1810 opening of the Wilts & Berks Canal and later the North Wilts Canal.

However, the real transformative factor came between 1841 and 1842 with the historic decision by Isambard Kingdom Brunel (what a great name that is) and Daniel Gooch to site their Great Western Railway works (aka God's Wonderful Railway) where they did. The rest, as they say, is history, and what a glorious history it is. Much of it is well documented but other aspects of it are less so.

Over the decades, Swindon's engineering and manufacturing associations have run the gamut. From BMW to Honda, Garrard record decks to Triumph lingerie and Bluebird toys with iconic aviation playing its part.

Less well known is that Swindon's rich history has a prehistoric element. Drain works in 1970s Walcot unearthed the bones of an icthyosaur – a marine dinosaur. The creature found fame on BBC's *Blue Peter* – what greater accolade for a town is there than that? You can see the icthyosaur's remains in Swindon's museum and art gallery.

As for culture and creativity, there are those that would have you believe that modern Swindon contains less culture than a yoghurt pot and therefore has nothing to offer. Don't let this assertion fool you. Swindon is a creative and cultural hotspot. It's home to artists and writers and musicians of every genre and calibre, past and present, and this book will examine some of them.

My route to writing this book comes via my blog, Born Again Swindonian. Formed in no small part to provide material for a university travel writing module, it set out to be positive about a town so often derided. As to why that is, I'm mystified. I started writing it back in 2013 when an English degree student at the University of the West of England and I'm still at it because there's so much to tell. The question is not what to put into a book such as this, rather it's one of what to leave out. Believe me, this is a small scratch in a large surface.

Swindon, then, is many layered. My hope with this book is to peel back a few of those layers and show how surprising Swindon is. Even when a thing is so obvious – a building for example – that you'd think to yourself 'what's secret about *that*?', there's something to learn, something of interest, something to incur a 'really, I never knew that' exclamation.

Swindon is so much more than a railway, as wonderful as that was, and a roundabout, as magic as that may be!

1. Before the Railway Came

Before the railway came Old Swindon was, as described in the introduction, an unimportant hilltop livestock market town, albeit one with a backdrop of Roman, Bronze Age and manorial history. Thus, when Richard Jefferies wrote in his 1875 essay *The Story of Swindon*, 'There is a family here whose ancestry goes back to the times of the Vikings; which was in honour when Fair Rosamond bloomed at Woodstock; which fought in the great Civil War. Nothing further. The real history, written in iron and steel, of the place began forty years ago only,' he simplified a tad.

Nevertheless, were it not for the coming of the canal in 1810 and then later the Great Western Railway, the chances are it would have remained the barely-worth-mentioning village on a hill. In that sense at least, Old Swindon is as much a part of the railway town as is New Swindon.

The Mechanics' Institution Trust library contains a slim volume bearing the snappy title *A Century of Medical Service*. Published in 1947 and written by Bernard Darwin (grandson of the naturalist Charles Darwin), the booklet chronicles the story of the GWR Medical Fund Society. An entity deserving of the eighth Wonder of the World title if anything did – if there were such a thing – and you'll learn why later.

In chapter one of his booklet, and quoting from *A Swindon Retrospect, 1856–1931* by Frederick Large, Mr Darwin writes:

> Old Swindon was a quiet little market town of considerable antiquity but no importance, set in a good hunting country and placidly interested in agricultural life ... In short it was a tiny country town wrapped up in its own affairs, having a good conceit of itself and not yet fully awake to the implications of the railroad and the horde of alien workers who were coming to the new village at the foot of the hill, and bringing fresh business to Old Swindon shops.

It's arguable that nothing much has changed in that respect.

In similar vein, in his 2005 *Swindon Decoded*, John Candler writes how Old Swindon grew from a medieval urban village complete with its lord of the manor to its seventeenth-century country town status. He describes it as a workday place of tradesmen and labourers, still lacking the whiff of polite society about it – something that only came after 1800. At this time, Old Swindon was of far less import than neighbouring Wootton Bassett (now Royal Wootton Bassett) and Highworth, which once had a larger population than Swindon. Between 1894 and 1974 Highworth was a rural district; now, though, it's part of Swindon's unitary authority.

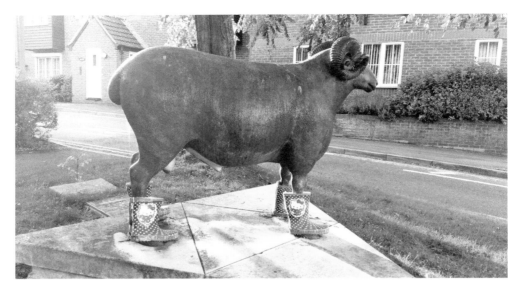

The Ram dressed in Hello Kitty wellingtons by some unknown wag.

Old Swindon's livestock market, opened in 1887, is long gone. The year 1988 saw the last sale there and some of the area now has mews housing on it. A bronze sculpture of a sheep marks what was the entry point to the sales yard – one of many public art pieces scattered across the town. This old Wiltshire horned sheep is the work of Jon Buck, one-time artist in residence for the then borough of Thamesdown. Old Swindon, or Old Town, today brims with independent coffee shops, cafés, restaurants and bars and has a thriving business community.

The Wilts & Berks Canal

Before the railway came there was the canal. When Brunel chose the route for his Great Western Railway he followed the Wilts & Berks Canal for some of its length. It's reasonable to assume the idea was to aid movement of the heavy materials, in the quantities needed, to construct the railway. In 1837 alone, the Wilts & Berks Canal transported 43,642 tons of coal from the Somerset coalfield, selling much of it en route – but with Abingdon wharf handling 10,669 tons. The canal became abandoned in 1914 – what you might call a victim of its own success given that the railway it made possible then took away its trade. These days, though some of the route is now built over, much remains intact. Increasing lengths of the canal are in water and in use by boats, including the trip boat *Dragonfly* that runs from Waitrose in Wichelstowe, tootles down the canal a bit then turns around and comes back again. It's a jolly pleasant way to pass an hour I can tell you. If you're wondering why it's called the Wilts & Berks Canal rather than the Wiltshire and Berkshire Canal the answer lies with a lazy draughtsman. It's thought that when drafting one of the Acts of Parliament the said draughtsman abbreviated the county names for his own convenience and it stuck!

Bevan's bridge on the Wilts & Berks Canal with Waitrose in the distance.

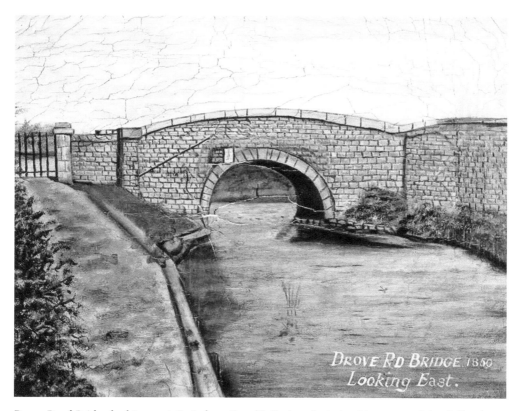

Drove Road Bridge looking east, Swindon, 1850. (G. Puckey, Swindon Museum and Art Gallery)

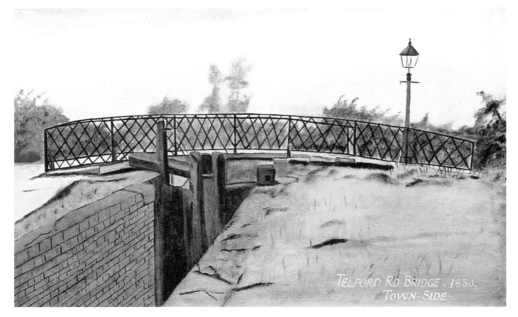

Telford Road Bridge, Swindon, 1880. (G. Puckey, Swindon Museum and Art Gallery)

Lords of the Manor

Thus it was then that the Goddard family, prominent landed gentry, lorded it over the people of Old Swindon. Established at Upper Upham House, near Aldbourne, from at least the late fifteenth century, they became lords of the manor of Swindon in 1563 when Thomas Goddard bought the Swindon estate known as Lawn.

While over to the west, before Brunel and Gooch had eaten their infamous picnic and New Swindon twinkled in their engineer's eyes, the St John family held court on their Lydiard country estate. At this point in history, the Lydiard estate and its residents are discrete from Old Swindon, but as New Swindon burgeons and the Works (referred to by Swindonians as the Works or Inside) grow the St John family made their presence felt, as you'll discover as you read on.

The Goddard family, meanwhile, exerted their influence in their own sphere. When the GWR first proposed their plans to site the Works at Swindon, the foot of the hill (now Victoria Hill) on which Old Swindon sat was their preferred location. There were good practical reasons for this: close access to the town, its people and its facilities. Yet, as Mike Pringle writes in *Swindon: Remembering 1914–1918* Gooch and Brunel were thwarted by the Goddard family. In the end the Works were sited 1 mile further north. With that came a need for housing and facilities, but it took until 1900 for the two towns to be joined as one and for houses and side streets along Victoria Road to spring up. Fitzroy Pleydell Goddard (son of Ambrose Lethbridge Goddard) gave the newly joined up town a mayoral chain. He also gave land for the County Ground (home of Swindon Town football club) and the Town Gardens. Before all that, though, in 1887 Ambrose donated an acre of land in Okus, in Old Town, for the Queen Victoria Jubilee Hospital.

Hidden in Plain Sight

Now you wouldn't think it could be possible to hide 50 acres of parkland, yet somehow Swindon manages it. Behind what's left of the gate piers (there would once have been adjoining lodge houses) in the image you see below, and down an avenue is an area of parkland, called Lawn. If you didn't know it was there you wouldn't know it was there – if you get my drift?

Standing on a busy traffic thoroughfare that once was Old Swindon's High Street, this portal bears no indication of what lies beyond. Only when you walk through them and down the avenue a little way, do you see an information board giving you a clue. Which explains why I spent quite a good while in a state of confusion about this park's location. What *is* beyond the gates – down the avenue and across the parkland – is this glorious vista.

The view from Lawn across to Highworth.

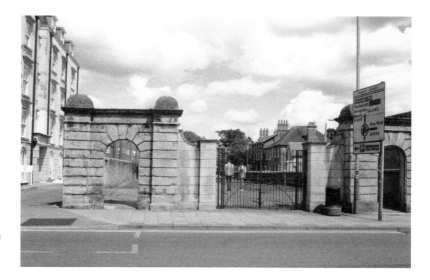

The remains of the gate piers on the High Street in Old Swindon.

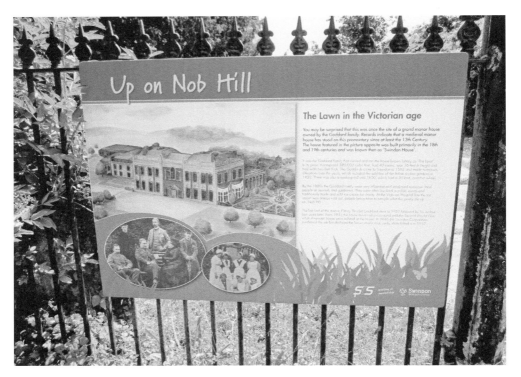

Information signage about Lawn parkland.

As is the way with stately homes and manor houses right across our green and pleasant land the Goddards were masters of all they surveyed.

In its heyday, as we've seen, Lawn was the house and estate of the Goddard family. Their tenure as lords of the manor of Old Swindon ended in 1927 when Fitzroy Pleydell Goddard died. Their family pile boasted a library, billiard room and gunroom while outside they enjoyed an arboretum, artificial lakes and an Italianate garden. Sad to say the house is long gone. You can still see remnants of the Italianate garden, and you can sit on a set of stone steps, set now in splendid isolation in the parkland, and admire the view to Highworth. The Goddard name lives on in the nearby pub and hotel the Goddard Arms and in several street names – Goddard Avenue and Fitzroy Avenue to name two – and The Lawns housing estate. Their estate is now public parkland used and loved by many Swindonians, once they've found it that is.

Old Swindon's High Street and the site of Christ Church formed the boundary of the Goddard estate. It's worthy of note at this point that the designer of Christ Church was Gilbert Scott Thomas who also designed St Pancras station and the Albert Memorial. The *c.* thirteenth-century Holy Rood was a near neighbour. Although a Norman church, the ruins have a touch of the 'goffick' about them. No giant leap of imagination is needed to picture ghosts and ghouls floating about between the remaining arches.

In the 1850s the Goddard family donated the land for the building of a new church, Christ Church, at the top of the hill.

DID YOU KNOW?

The term 'Holy Rood' is an Anglicisation of the Scots 'Haly Ruid' meaning holy cross and possibly refers to the relics of the true cross on which Jesus died.

Holy Rood is the location of a footnote in English Civil War history and what appears to be the only time, pre-nineteenth century, when Old Swindon gets a mention in national history.

Travelling back east with his army after relieving the siege of Gloucester in September 1643, the Parliamentarian Robert Devereux, Earl of Essex, camped close to the town. He took communion in Holy Rood, it being the nearest place of worship, using his own chaplain rather than William Gallimore, the local vicar.

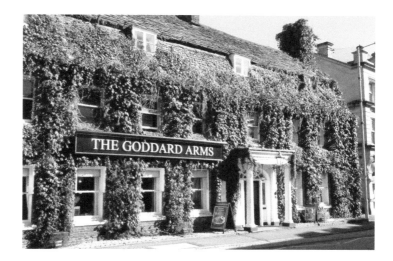

The Goddard Arms Hotel on Old Town's High Street.

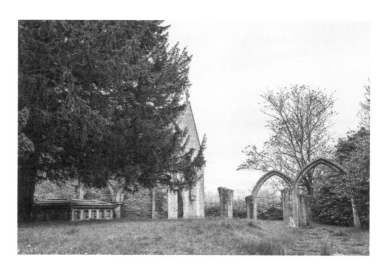

The chancel and these arches are all that remain of Holy Rood. (Photo credit Daniel Webb)

Lydiard House & Park and St Mary's Church

I live on the west side of Swindon. Here, before the railway came, there were green fields and farmers' fields surrounding a number of farms. The hamlet of Shaw sat next to Nine Elms through which the bus from Purton passed. On the edge of it all was, and is, Lydiard House and Park, the erstwhile home of the St John family, whose lineage is traceable back to the start of the Tudor dynasty.

Built in the 1980s, my estate forms part of an extensive and now well-established urban conurbation edging Lydiard. Where there are now thousands of homes there once were tenant farms, remnants of which you can see here and there if you look hard enough. The historic and beautiful 260-acre Lydiard estate features a Palladian house, a walled garden and St Mary's Church. Dating back to the twelfth century, St Mary's is a delightful country church featuring box pews and fifteenth-century wall paintings covering most of the nave. The paintings include the usual suspects: St Michael weighing souls and St Christopher too. There's a depiction also of the martyrdom of Thomas à Becket and a painting of the head of Christ in the south porch. I'm informed that few churches in Britain feature paintings inside the porch so this one in Swindon, surrounded by a floral design, is a rare feature.

Though packed with monuments to the St John family of Lydiard House, St Mary's was never the St John family church. Rather its role was as the parish church for Lydiard Tregoze, a village that disappeared 300 years ago, probably as a result of plague. It simply happens to be adjacent to the original Lydiard manor house.

St Mary's Church in Lydiard Park, West Swindon.

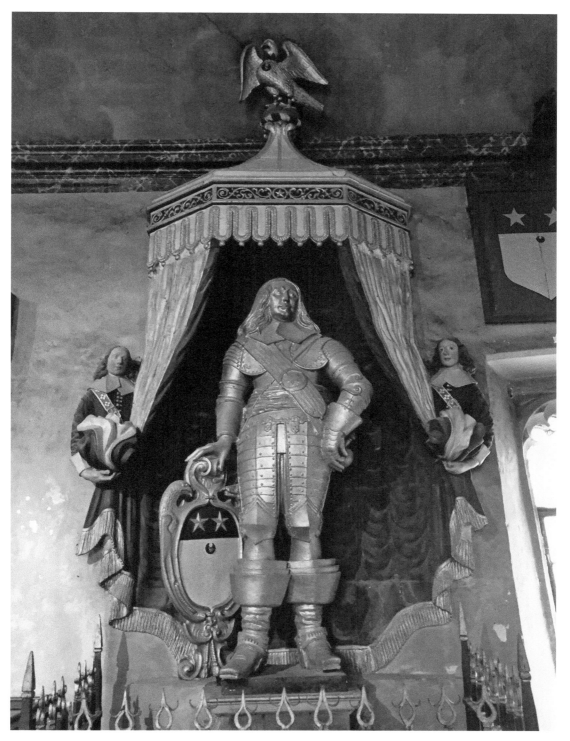

The Golden Cavalier monument to Edward St John in St Mary's Church. (Roger Ogle)

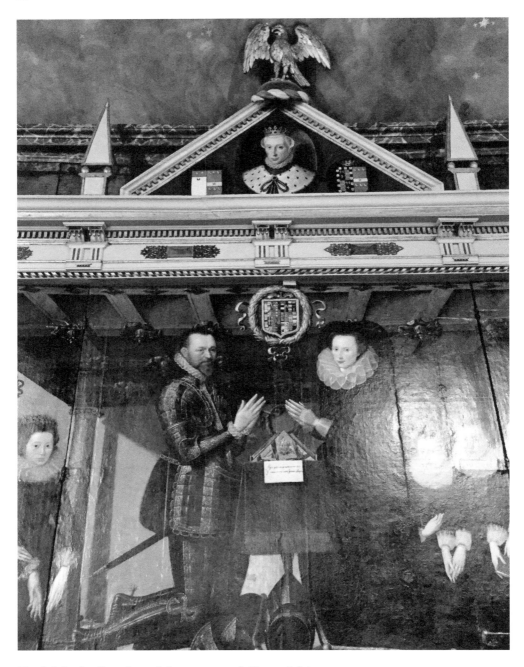

The St John family polyptych, here unopened. (Roger Ogle)

Well the same is true of Cheny Manor – yet more manorial land dating back to 1242 when Ralph Chany owned the manor. While Dorcan is a distant echo of a small Roman town that went by the expectorant-cough-mixture sounding name of Durocornovium, these and more, before the railway came, were ancient parishes incorporated into New Swindon as its wings spread.

Counted among the St John family monuments the church contains is the splendid Golden Cavalier. Erected by John St John in 1615, the effigy commemorates Edward St John, a Royalist commander. Poor Edward had the misfortune to die of injuries sustained in the English Civil War's Battle of Newbury. The effigy was originally painted black to imitate marble, the gilding being a later enhancement.

A further, important monument in the church is the polyptych of the St John family. Located in the church's chance, it's opened on high days and holidays giving visitors a chance to appreciate its full glory It is quite an extraordinary thing and you need to see it to appreciate its splendour. The attention to detail on it is staggering: each face is painted individually rather than, as was common practice, a generic face for all. Commissioned by Sir John St John (the 1st Baronet), this painted polyptych (eleven panels) is thought to be the creation of one William Larkin. It comprises one of three commissions undertaken by the baronet in commemoration of his parents, Sir John St John (d. 1594) and Lucy née Hungerford (d. 1598).

The St John Tomb

Rather than entrust the task to his descendants, the 1st Baronet St John designed his own memorial. He had it erected in 1634 when not yet fifty years old. The St John monument commemorates the baronet, both wives and his thirteen children.

DID YOU KNOW?
In 2004, writing about St Mary's, historian and writer Simon Jenkins commented, 'Were the south chancel removed, lock, stock and barrel to London's Victoria & Albert Museum it would cause a sensation.'

Earlier I mentioned how the coming of the Wilts & Berks Canal in 1810 made possible the later birth of New Swindon. Returning to *Swindon Decoded*, John Chandler writes how, gazing back over fifty years of hindsight, the old William Morris (founder of the *Swindon Advertiser*) and the young Richard Jefferies both saw the seeds of New Swindon in the arrival of the canal. 'It was the first push,' wrote Jefferies.

That mention of Richard Jefferies segues neatly into chapter two. There we step into the Victorian era and learn more about his life and times. We also meet Edith New, Swindon's celebrated suffragette, and Alfred Williams, aka the Hammerman Poet.

2. The Victorian Era Part One: Two Writers' Lives and a Suffragette's Struggle

John Richard Jefferies (1848–87): Threads

Author Will Self, gardener Monty Don, broadcaster Tony Robinson, film-maker Jeff VanderMeer and the National Trust nature specialist Matthew Oates. A disparate collection of people indeed. Yet there's a common connecting thread between them all. If Richard Jefferies is a thread weaving itself in and out of much of this book, he's also the common thread between the souls mentioned above. How so? Because they all confess to a love of, and respect for, Jefferies' writings. If I now hear 'Richard who?', I'm not surprised. It's fair to say his fame is somewhat greater in Surbiton, whose library celebrates him with a wooden plaque, than it is in Swindon. Yet those who know Jefferies' writings find inspiration in him. While he may be forgotten by many, this doesn't mean he wasn't good and isn't worthy of our appreciation. Indeed, gardener and broadcaster Monty Don describes him as a great laureate of the English countryside, one not heralded nearly enough. Something to ponder on when next you're mulching the rose beds. Not that it was always the case in Swindon – there used to be memorial days to him.

Portrait of Richard Jefferies aged thirty.

Richard Jefferies' Day.

Burderop, Nr. Swindon,

(by kind invitation of Col. T. C. P. CALLEY, C.B., M.V.O.)

Saturday, July 6th, 1912.

SOUVENIR PROGRAMME.
ONE PENNY.

Right: Programme cover for a Richard Jefferies' Memorial Day, 6 July 1912, at Burderop. (Reproduced with permission from Local Studies, Swindon Libraries)

Below: Ticket to the second annual Richard Jefferies' Day. (Reproduced with permission from Local Studies, Swindon Libraries)

Workers' Educational Association,

SWINDON BRANCH.

SECOND ANNUAL

Richard Jefferies' Day

BURDEROP (by kind invitation of Col. T. C. P. Calley, C.B., M.V.O.).

SATURDAY, JULY 6th, 1912.

SPEECHES. MORRIS-DANCING. OPEN-AIR CONCERT.

PICNIC TEA AT 4-30 P.M

Tickets, 8d. each. (If purchased before Tuesday, July 2nd, 6d. each).

We once were all much more in tune with the natural world than we are now, though environmental awareness is rising – albeit not as fast as sea levels in some parts of the world. Jefferies though was always in accord with, and passionate about, his surroundings – he loved the countryside and rubbing shoulder with the abundance of nature. Matthew Oates of the National Trust said,

Now, as our severance from nature widens, so Jefferies' messages increase in importance. The prospect of Sir David Attenborough, one of his successors, lying forgotten a century from now beggars belief – yet this is precisely what has happened to Jefferies, the most deeply spiritual of our nature writers and the first and truest nature conservationist. His message is simple: in nature we truly belong.

However well known Jefferies might be in UK academic circles or even to the general reading public, and I venture to suggest not that much (Surbiton aside), he remains unknown to a great many Swindonians – born again or otherwise. I'd been in Swindon many years before I got around to visiting his birthplace and childhood home. In my defence, this lamentable situation was difficult to address, what with the museum only being open for about thirty minutes a month on a weekday and me in full-time employment. Only the slightest of exaggerations believe me. If keeping a son of Swindon and his museum and life's work a secret is your aim, then barely opening said museum is a genius tactic. But rejoice, for the sterling work of Mike Pringle, Hilda Sheehan and their green team, the Richard Jefferies Trust, have wrought a transformation at Coate farmhouse home.

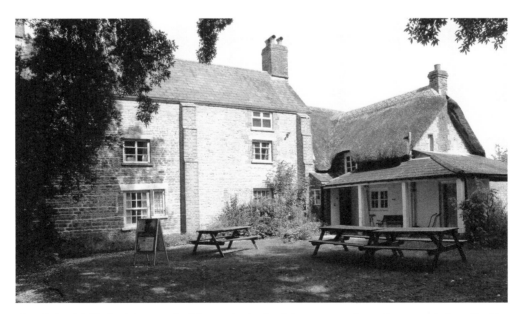

The Richard Jefferies Museum (looking at the back of the museum from the garden), described by Tony Robinson as idyllic. He's right. It's a lovely place.

The Richard Jefferies Trust – aka the Green Team

The Richard Jefferies Trust (RJMT) is a registered charity created to develop and run the museum. Taking the reins in 2015, they've achieved a phenomenal amount since then. The trust's mission statement says well enough what they're about: 'To create/ share a unique environment of discovery that will enrich people's lives and inspire adults and children through the home, writing and thoughts of Richard Jefferies.' The best thing to do, though, to understand their ambition is to go and see them. Visit on a summer afternoon and enjoy a cream tea in the garden. You might even get jam made from the garden's mulberry tree, which was immortalised by Jefferies in a poem. Here's the first stanza:

'THE MULBERRY TREE'

Oh, mulberry tree, oh mulberry tree
Dear are thy spreading boughs to me.
Beneath their cool and friendly shade
My earliest childhood laughed and played.
Or, lips all stained with rich red fruit
Slept in the long grass at thy root.

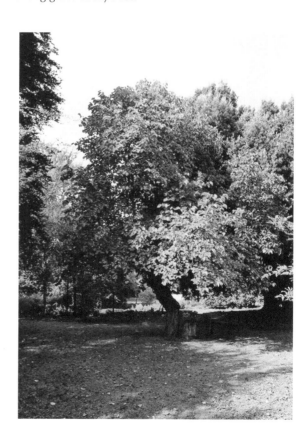

The Mulberry tree in the Richard Jefferies Museum garden.

A Swindon Story

Richard Jefferies' farmhouse birthplace was then in the middle of the countryside – now it's close to housing estates, edging the Coate Water park. In the last cohort of Swindonians baptised at Holy Rood Church (January 1849), Jefferies found fame in his day for his prolific and sensitive output on natural history, rural life and agriculture in late Victorian England.

Jeffries wrote more than one account of Swindon's origins, one of which is the 1875 *The Story of Swindon*. In this essay Jefferies describes, in detail bordering on bucolic, a tale of Gooch and Brunel deciding the location of the locomotive repair depot on the toss of a sandwich. That the infamous 1840 picnic, mentioned in Chapter One, took place there is no doubt: Gooch recorded it in his diary. As for the throwing of the sandwich, these young men were brilliant engineers. The notion that they based their history-making decision on the bounce of a bacon butty is apocryphal for sure.

In early 1866 Jefferies began work as a reporter for the *North Wiltshire Herald*, and also the *Wilts and Gloucestershire Standard* and the *Swindon Advertiser*. At the latter publication he found encouragement for his writing attempts from William Morris, the paper's founder. Jefferies had ambitions to get publication and employment with London

One of the interior rooms at the Richard Jefferies Museum.

publishers. So, in 1877, together with his wife and baby son, Jefferies moved to Tolworth, near Surbiton – hence his fame there.

Of his early years in Swindon, the museum is quite the best place to discover him. Jefferies' birthplace is a cornucopia of books, pictures and artefacts, most of which are under ownership of the Richard Jefferies Society. Far from being a fossilised place the museum is alive with innumerable family events run by the RJ Trust. It's also the home of Poetry Swindon and a running club. One can pass a pleasant couple of hours following a trail round Old Town taking in locations relevant to his youth and early adulthood. The house on Victoria Hill seen in the image below, bears a plaque declaring 'Here lived Richard Jefferies 1875–1877'. For its presence we have the North Wilts Field and Camera Club to thank as it was their initiative. Before the 1901 unveiling ceremony performed by Lord Avebury, a reception took place attended by the mayor, Lord Edmund of Fitzmaurice MP, and a host of other dignitaries, who gave addresses in praise of Jefferies.

Affording ample opportunity to try out Old Town's many coffee shops and bars, the Richard Jefferies trail is an enjoyable way to pass a couple of hours. My favourite thing on the trail, simply because it's tucked away unnoticed and unmarked, is the squeeze-belly stile you see in the image. The path beyond it leads to Coate, a path that Jefferies used when coming and going between his home and Old Swindon.

Richard Jefferies' Old Town home and plaque on Victoria Hill, Old Town.

Jefferies rejected Darwin's evolution theory denouncing it as a modern superstition, proceeding on assumption alone: 'what there is, what was the cause, how and why, is not known.' One wonders what Bernard Darwin, of GWR medical history and grandson of Charles, would have made of that? Yet, conversely, he had huge interest in many matters of science – in particular the flight of birds and insects and the possibility of man developing flying machines.

Writing with a clear respect for the men of New Swindon, Jefferies draws, in *The Story of Swindon*, a comparison between the middle classes for whom he is writing and the men labouring in the Works. This comparison doesn't show favour to the former: 'They are probably higher in their intellectual life than a large proportion of the so-called middle classes ... the great and well supplied reading room of the Mechanics' Institution is always full of readers ... where one book is read in agricultural districts, fifty are read in the vicinity of the factory.'

As Richard Jefferies' life staggered to a premature end when not yet forty years old, Edith New was growing up into a new era of political awareness for women, one that saw an historic fight for women's right to vote shake the country.

DID YOU KNOW?
E. H. Shepard, of Winnie the Pooh fame, illustrated *Bevis*, Jefferies' novel for children based on his own childhood.

Liddington Hill is a Wiltshire spot that both Richard Jefferies and Alfred Williams (1877–1930 aka the 'Hammerman Poet'), held much love for, which explains why they're both commemorated there on a spot marked by a triangulation pillar.

In 1938/9, support from PM Neville Chamberlain, John Betjeman and others led to the installation of a joint memorial plaque. American forces personnel stationed at Chiseldon as part of the 1944 D-Day preparations took to using the plaque for target practice causing its removal. You can now see it in the Richard Jefferies museum.

As a Millenium project, Liddington Parish Council erected a sarsen stone bearing new dedication plaques and a direction marker next to the Trig point.

Jefferies' wanderings across Wiltshire's downlands inspired his rapport with nature, something he expressed in his autobiography *The Story of My Heart*. Jefferies view from Liddington Hill was one, 'over broad plain, beautiful with wheat and enclosed by a perfect amphitheatre of green hills'. Suffice to say it's much changed now.

Squeeze belly stile used by Jefferies when he walked the path between his Coate farmhouse home and Old Town.

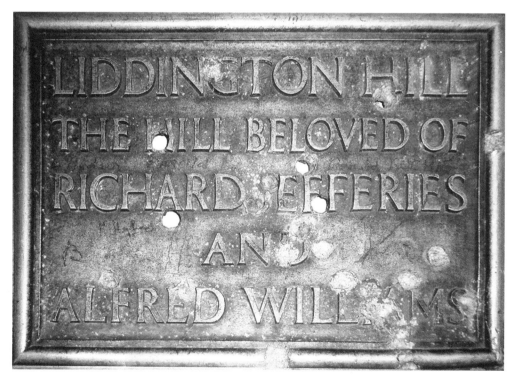

The original Jefferies/Williams memorial plaque at Liddington showing the bullet holes incurred by American forces personnel.

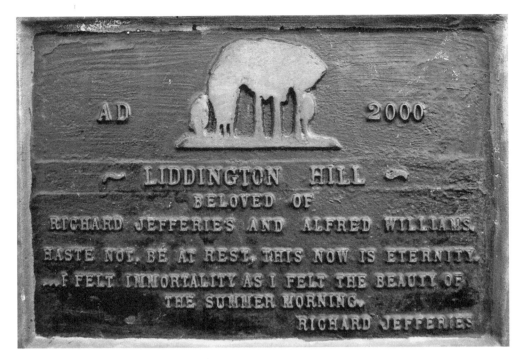

The replacement plaque on the Williams/Jefferies memorial today.

Jefferies rests in Worthing where he lived at the time of his death from tubercolosis in 1887, aged thirty-nine.

Edith New, 1877–1951: Never Surrender! Never Give Up the Fight!

There couldn't be a more fitting time to mention Edith New in a Swindon-related book than now, 2018, the centenary of the granting of the vote to *some* women. I say *some*, because British women were only initially granted the vote if over thirty, owned a property or were in receipt of a university education.

That Swindon has heard Edith's story at all is down to the efforts of local historian Frances Bevan and the producers of *Swindon Heritage* magazine. Because of them, Swindon's first blue plaque lies on the wall of No. 24 North Street, Edith's birthplace. For a detailed history of Edith, I point you to their writings and to the local studies people in the central library. They're the fount of all Swindon knowledge and my debt to them is huge. You might also keep an eye out for a further publication from Frances, *Struggle and Suffrage in Swindon*, which will hit the shelves later this year.

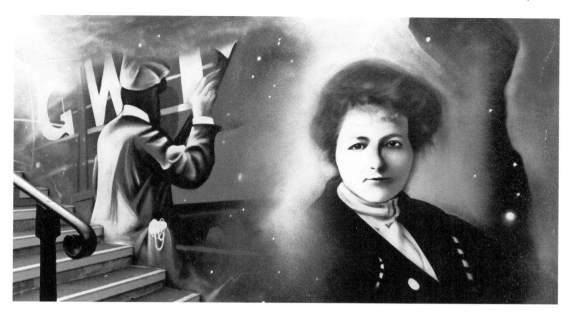

Above: Edith New as seen on the Cambria Bridge mural.

Right: Results of the suffragette demonstration showing Miss Edith New and Mrs Leigh in court for window breaking at No. 10 Downing Street. (Reproduced with permission from Local Studies, Swindon Libraries)

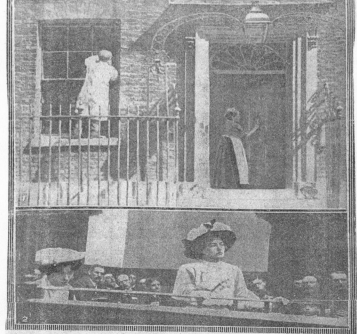

RESULTS OF THE SUFFRAGETTE DEMONSTRATION.

WOMEN IN COURT WHO BROKE THE PREMIER'S WINDOWS

Of the twenty-nine suffragettes who appeared in the police-court yesterday two had to meet a more serious charge than that of obstructing the police in the execution of their duty. These two were Miss Edith New and Mrs. Leigh, who were sentenced to two months' hard labour for window-breaking at 10, Downing-street. (1) Mending the broken windows. (2) In the dock, Miss New standing.

and imprisonment for six weeks.

PLATFORM No. 29.
Miss Edith New.

The last platform will be presided over by Miss Edith New, who is best-known for her protest at No. 10, Downing-street, when she chained herself to the railings. She was born on March 17, 1877, at Swindon, Wiltshire. She served her apprenticeship as teacher in the public elementary schools of Swindon from 1893-7, and obtained a parchment certificate after two years' training in Stockwell College. After 18 months' work in Swindon she came to London, and taught in the [...] of E. Greenwich and Deptford till January, 1908, when she became one of the staff of organisers for the N.W.S.P.U.

She was first interested actively in the women's movement during the autumn of 1906, after hearing the speakers at a meeting in Trafalgar-square. She was arrested in March, 1907, and given a term of two weeks' imprisonment for an attempt to get to the House of Commons, and again in January, 1908, for the demonstration outside Downing-street mentioned above. This resulted in imprisonment for three weeks in the second division. On her release, she said that she was quite ready, if need be, to repeat the offence, which was qui[...]

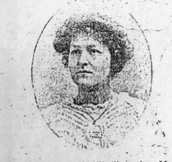

"worth the whipping." Since then M New has been actively engaged in election work at Hastings, Peckham, a North-West Manchester.

Newspaper clipping, Platform No. 29. (Reproduced with permission from Local Studies, Swindon Libraries)

Schoolteacher Edith's role in the suffragette struggle was far from insignificant. She served several jail sentences, though there's no evidence that she suffered the vicious indignity of force-feeding. Edith hit at the establishment in every sense when she, and her partner in crime in the cause, Mrs Leigh, lobbed a stone at No. 10, smashing windows, an act that gained them two months' hard labour. Not content with breaking windows, Edith also took groundbreaking action in chaining herself to the railings at No. 10 Downing Street, the first time the suffragettes had employed the tactic. The unprepared police took some time to get her free. Their feeble fumbling with a file gave Edith enough time to make her protest heard to the assembled cabinet. A three-week sentence in Holloway ensued.

Resigning from teaching in 1908, Edith joined the WSPU (Women's Social and Political Union) paid workforce. With them, she travelled the country gathering support from parliamentary candidates sympathetic to the movement. During this period Edith was

again at the forefront of radical action. When imprisoned in Scotland she and her fellow prisoners were the first to go on hunger strike there.

Throughout her actions and resulting punishments Edith was ever defiant and stoic – as demonstrated in the newspaper clipping shown. In typical British, understated style, she declares: 'If need be, I will repeat the offence, which was quite worth the whipping.'

Though women have much ground to cover to reach equality, we owe Edith New and her peers the biggest vote of thanks for their fortitude against the odds.

Alfred Williams, the Hammerman Poet, 1877–1930

We can draw comparisons between Alfred Williams and Richard Jefferies. Both were men of the earth, each holding deep affection for the Wiltshire countryside and featuring it in their writings. Both, as we've seen, loved Liddington Hill. There though the similarities between one writer's life and another end. Jefferies found fame in his day with his writings, carving out for himself a successful journalistic career. Williams on the other hand, during his lifetime, sold a bare handful of his masterpiece *Life in a Railway Factory*.

Born in the same year as Edith New, Alfred Williams also entered the world into a working-class background. Edith's father died in a yard accident at the Works when she was barely a year old. By fourteen years of age she worked as a teacher at Queenstown Infant's School before later moving to London to teach. Not the best of life starts you might think, but it was a whole lot better than Alfred Williams'.

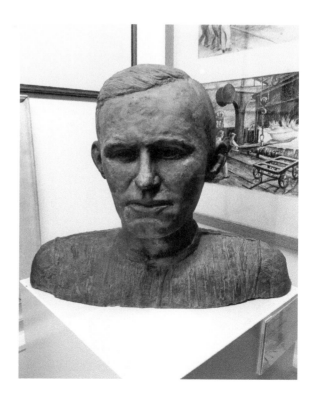

Alfred Williams bust, sculpted by Carleton Attwood, in Swindon's Museum and Art Gallery.

It's somewhat surprising that he even reached adulthood at all given that records show the young Alfred to be a mite accident-prone. In 1879 the two-year-old Alfred wandered outside in his nightclothes and fell into a disused well. Rescue from that predicament wasn't the easiest. He escaped suffocation from the sewage by the narrowest of margins. A few months after that incident he almost drowned when fishing for minnows. Then in 1880, aged three, he had an altercation with a market gardener's cart, the wheels of which passed over his stomach.

When Alfred was around four or five years old his mother became a single parent. Whether Alfred's father left of his own accord or was asked to go isn't clear. Either way, the event forced young Alfred's mother to move her brood to Rose Cottage, close to his South Marston, Cambria Cottage birthplace.

The rudimentary education Alfred received was soon usurped by the need to get farm work to support the struggling family. Working on the land though provided a precarious living and Alfred faced a harsh choice. His heart belonged to the fields and the outdoors but he couldn't justify ignoring the security and better pay of the Works, as soul-destroying for him as it was. Thus, like Edith New's father and his brothers before him, to the Works he went. Yet the young man forced to give the best years of his life to the stamping shop compensated by educating himself and following his creative urges in his downtime.

You can imagine what a scant amount of spare time Williams would have had – lunch breaks at work and snatches at home. Yet he set about learning the classics, reading

Rose Cottage.

Shakespeare, experimenting with painting and learning Greek, Latin and French to further his education. Legend has it that in his breaks at work, he'd chalk Greek and Latin letters on his furnace to learn them.

By the time Alfred was twenty-one he'd written *Sardanapalus*, a verse play – though that remained unpublished. Another five years passed before he got his first book into print. In 1909 the first of six poetry collections *Songs in Wiltshire* went into publication. In 1911 *Poems in Wiltshire* followed with *Nature and Other Poems* hot on its heels in 1912. That year saw too the publication of his first book of prose. This observation on South Marston life, *A Wiltshire Village,* painted so realistic a portrait that it caused something of a furore. The story goes that half the village complained because the book featured them and the rest complained because it didn't and the vicar, in high dudgeon, set fire to two copies: his own and the one in the village reading room.

Alfred's reputation grew and his work was well received enough for *The Times* to take notice of him, though it was another national that bestowed on him the epithet 'the Hammerman poet', taken from the nature of his toil in the Works. There's another title applicable to Alfred though, that of Swindon's war poet. At the end of 1915 *War Sonnets and Songs* hit the printing presses, work of which he was himself later dismissive.

Unfortunately none of this gave him the financial freedom to leave the factory. Only the generosity of benefactors and support from friends allowed him to carry on publishing. Through the efforts of friends, three different prime ministers heard of his financial plight but couldn't authorise the civil pension for him. That said, he did receive some

Alfred Williams' own copy of his book *Life in a Railway Factory*. (Reproduced with permission from Local Studies, Swindon Libraries)

one-off lump sums and was finally granted an annual pension by Ramsay MacDonald in 1930. The sadness of that being that it came less than a month before Alfred's death. His wife Mary died only seven weeks after him.

By 1914, dogged by ill health, Alfred left the railway works scrawling *Vici* (I conquered) in chalk above his furnace as he went. If nothing else, leaving the Works gave him the chance to complete *Life in a Railway Factory*, the warts and all exposé of life *inside* that he'd begun in 1911. Williams' biographer Leonard Clark described the book as the bravest and most comprehensive condemnation of factory life to appear in Europe in thirty years. Alfred himself was pleased with his work, saying it was 'the only good book on factory life that we have in England written by a working man.' Without doubt his book made an important commentary on the history of Swindon and a landmark documentary of British industrial life, yet it sold only a dozen copies in Swindon in the six years after its publication.

Alfred's Legacy

Alfred already has two titles, but we can attribute a third one to him: social historian. He left behind his poetry and his prose yes, but he did something else too. He appointed himself a collector of Wiltshire folk song lyrics to prevent their disappearance. This undertaking was mammoth. He visited ninety-seven towns and villages on his bike, covering something like 7,000 miles (take that The Proclaimers!) to collect over 1,000 songs. He'd have to have done this in the winter months, in the hours of darkness as during summer time and daylight hours, agricultural workers, from whom he collected the lyrics, would be hard at work.

The lyrics Alfred collected are all available online on Wiltshire Council's community history web site. In 2012, folk supergroup Bellowhead honoured Alfred's song-collecting feat on their album *Broadside.* One of the album's tracks, 'Betsy Baker', is based on lyrics collected by Alfred in 1914–15.

Alfred recorded of this song: 'This song of Betsy Baker was formerly well known at Shilton and Brize Norton. I have not heard of it elsewhere. It is probably scarcely complete, but it is the only version I could find. Obtained of Job Gardner, Shilton, near Burford.'

You have now met a suffragette and two contrasting writers' lives. In chapter three I'll take you on a visit to the Mechanics' Institution, show you a superlative medical fund and tell you of a vexed viscount.

3. The Victorian Era Continued: A Mechanics' Institution, Healthcare Light Years Ahead of Its Time and a Very Vexed Viscount

Better people than me – *proper* historians rather than an enthusiastic blogger – have written about the GWR Works and the magnificent machines produced there. No need for me to bother then. Instead we dip into Swindon's Mechanics' Institution, the GWR Medical Fund Society, a trendsetting library and a victory for people power. First though, some important context.

There's no denying that Swindon's Mechanics' Institution is in a sad state today, yet its prospects for restoration in 2018 are encouraging. It's been a long time coming, I know, but Swindon's Mechanics' Institution is gaining increasing recognition as being nationally and even internationally significant. We should note that although this wasn't the first Mechanics' Institution, it's possibly the largest and longest serving of more than 700 around the world. Many were established in Australia, New Zealand, Canada and the USA, with Swindon's recognised as among the best.

As a movement, the Mechanics' Institutions began in Scotland. The first one opened in Glasgow in 1823. It was self-governing and self-supporting and led to a move to a national movement. Other establishments followed around both Glasgow and Edinburgh before the idea spread south to London and from there to the regions. The Mechanics' Institutions (and a range of Mining and Engineering Institutions) were characterised by libraries, lectures, entertainments, and social action created both by and for working people in an era of breathtaking social and industrial change. Such initiative is a source of inspiration and underpins the on-going effort to recreate Swindon's institution today.

While we're busy noting important things: the GWR were no Cadbury or Rowntree bestowing this facility upon its men in a fit of paternalistic benevolence. They did *help* the men to set up the institution – that much is true. But the extent of their involvement went not much further than that. Rather, the men themselves were its chief driving force. As Daniel Rose, director of the Mechanics' Institute Trust, observed in Martin Parry's wonderful, must-see *Railway Town* film, the GWR were skilled at getting their name on everything but at paying for nothing.

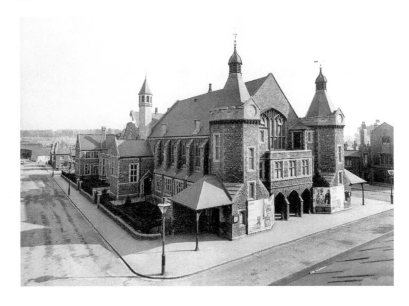

Swindon's
Mechanics'
Institution, c. 1930.

An Early Lending Library

In 1850, the United Kingdom's Parliament passed the Public Libraries Act, giving local boroughs the power to establish free public libraries. The Act formed the first step of legislation that created a lasting national framework for the provision of universal free access to information and literature. It was a litmus paper of the times, indicating the educational, social and moral concerns of the period. Not that the Act was without contention. Of several concerns expressed about it was a worry that it would infringe on private enterprise and existing library provision such as that of the mechanics' institutes. Swindon's Mechanics' Institution was in this, as with so many things, ahead of the curve.

In August of 1843 a group of employees, thought to be from O shop (the Works tool room), collected together a few books given to them by friends to lend to each other. This early book-lending arrangement pre-dated the Public Libraries Act of 1850 by seven years and, by nine years, the opening of the Manchester Free Library – the first to open under the provisions of the 1850 Act.

These few books formed the basis of one of, if not the, earliest lending libraries in the country. What's more it was open to everyone living in Swindon. The collection grew into something so broad and so deep that the borough of Swindon didn't establish its own collection until 1943. When they did get around to it, it drew upon the Mechanics' collection as its basis. A notable part of the new library services offering was, and is, the amassed local historical material. Today this material forms the core of a vast and ever-growing Local Studies Collection at Swindon's modern central library, which was built in 2005. Swindon's local collection has a reputation for being one of the finest of its kind in the country, holding many books about Swindon. It's hard to imagine another town of Swindon's size where so many of its people will have thought it as important to record their work and their lives as Swindon's.

The Mechanics' Institution Is Formed

Swindon's early lending library then came into being before the Mechanics' Institution itself. A year later, 1844, saw the formation of the new Swindon Mechanics' Institution as an entity constituted to benefit and enlighten those employed by the GWR. Observe that non-GWR workers were allowed to join as open members, thus making the institution an open body. The Mechanics' Institution provided for practical needs suggested, for the most part, by the men themselves. Furthermore, the men managed it themselves. Note too that the Mechanics' Institution existed as an organisation well before the building itself. A decade went by before Swindon's Mechanics' Institution got its premises. On 24 May 1854, Lord Methuen, assisted by Daniel (later Sir Daniel) Gooch, laid the foundation stone – an event of great celebration.

A Mechanics' Institution Stone-laying Ceremony

Two accounts exist of this momentous occasion. William Morris, founder of the *Swindon Advertiser,* wrote one of them and a London journalist writing for *Builder Magazine* wrote the other. These are two widely differing accounts written for different audiences and with differing tones. The former article, written by a member of Swindon's 'glitterati' might be described as a mite sycophantic towards said glitterati. The latter is an unembellished, factual account. Morris does, though, make a noteworthy opening comment: 'Of the many changes effected in this country by the introduction of railways and railway travelling, in no instance has the change been more striking than in the case of Swindon.' Further, describing how the coming of the GWR caused Swindon to rise in note and importance he refers to Old Swindon as being 'situate in the centre of an agricultural district celebrated for its cheese, butter and bacon, and that in the neighbourhood there were some quarries which yielded stone of excellent building qualities'. In the current climate of library closures and cuts in music and arts provision in schools his observation about the importance and usefulness of the Mechanics' Institution is striking: 'It has had the effect of diverting the minds of the younger portion of the inhabitants into a channel pregnant with good things and throwing a genial influence around the neighbourhood.' A sentiment of which our leaders at all levels might do well to take note.

To convey to you what a big deal this occasion was I quote from *Builder Magazine* (Volume XII, 1854) 'A Visit to Swindon New Town': 'On the 24th of May, a large party left the new London station of the Great Western Railway Company by a special train for Swindon, where, when they arrived, they found that other trains had already discharged their cargoes, and that the town was literally full of people: flags were flying, brass bands blowing, and everyone was in a bustle.' More people came to this stone-laying ceremony than lived in Swindon at the time. Imagine that? How was that even possible on a Monday? A good question and the answer lies in the fact that the day happened to be a national holiday in honour of Queen Victoria's birthday. The date later became Empire Day and then Commonwealth Day. In Swindon, though, that date should forever be Mechanics' Day.

A Masonic Procession

Included in the figures playing a part in conceiving, designing and constructing the Mechanics' Institute were the Freemasons. As the article in *Builder Magazine* states:

> It was to lay the first stone of this proposed institution and market, with Masonic rites, that the gathering had taken place ... an amazing number of Freemasons attended, and displayed aprons, blue ribands, stars and other insignia to a marvellous extent.

By all accounts the Masonic procession was a formidable one. It included members of the Manchester unity of Oddfellows and the Ancient Order of Foresters attired in velvet coats and leggings. Unreported by William Morris, this article's author of writes an interesting and telling nota bene: 'the exemplary wife of one of the Freemasons would walk in the procession and was snubbed in consequence.'

Despite such involvement in the stone-laying ceremony, there's no evidence to suggest that the Freemasons bore any influence on the running and use of the building. That role fell to the works manager, and Vice-president of the Institution, Minard Rea, who together with an elected committee, ran the building with great success.

Construction of the Mechanics' Institution was swift. Indeed, it was so swift that by 20 December 1854 the building was sufficiently complete for it to host a rally and entertainment in aid of the Patriotic Fund for those wounded in the Crimean War. They erected a temporary wooden external staircase to let attendees into the upper floor

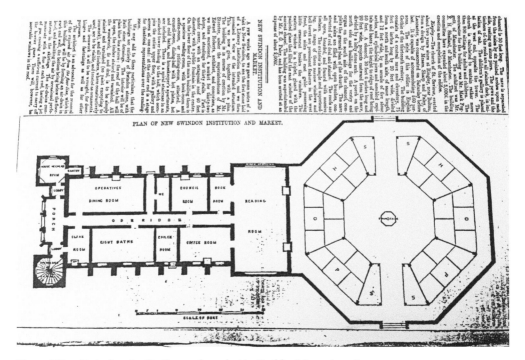

Plan of New Swindon Institution and market in *Builder Magazine*, 1854.

theatre. Final completion came in April 1855 with the new hall and ground floor facilities given a formal opening on Tuesday 1 May 1855.

An Institution Creates Another Institution: The Children's Fête

Dating back to 1866, the Children's Fête is Swindon's oldest summer event. Organised by the Mechanics' Institution, the fête ran until 1939 then halted for the duration of the Second World War. Gallons of tea were brewed and drunk at each fête and every child got a free piece of cake.

The Mechanics' Institution Trust (MIT) revived the fête in 2003 and maintain it to this day. The year 2016 marked the 150th anniversary of this particular Swindon institution.

1845 and the Need for Medical Provision Became Paramount

Railway growth was now at its height. The uniform housing of the Railway Village was underway but it couldn't keep pace with the influx of workers arriving to the developing town. With only basic sanitation contagious, diseases became rife. This then was no time to be poor – not in an era with no NHS and in a town hit by TB. This medical help came from the Medical Fund Society set up and run with extensive assistance from the Mechanics' Institution. Now here's another important thing to note: the GWR Medical Fund Society was neither GWR company initiative nor GWR company policy. The workforce started it, the workforce paid for it and the workforce ran it via elected officers. The GWR supported it of course. After all, why wouldn't they? It cost them nothing and freed them of all responsibility for caring for their workforce. Remember what I said earlier about the astonishing talent the GWR had for getting the credit without putting their hands into their pockets?

1847–1947: A Century of Medical Provision from the GWR Medical Fund Society

I dislike the word unique – as many of my business clients will testify. It's clichéd and, anyway, few things are. Yet the word can, with justification, be applied to the GWR Medical Fund Society. Not though in the fact of the fund's existence. Just as there were other Mechanics' Institutions in the country there were other medical funds too. Notably in Tredegar in Wales, the birthplace of one Aneurin Bevan, the godfather of the NHS. The Tredegar Medical Aid Society, though, was newer, founded in 1890, and not as extensive as Swindon's model. What made Swindon's MFS so special was its length, its breadth and its scope. The Swindon model took a modern and holistic healthcare approach symbolised by the dispensary and baths at Milton Road.

'From cradle to grave' is an expression synonymous with the NHS. Yet Swindon can lay claim to offering that level of care decades before Britain got its NHS. The GWR Medical Fund Society gave an inclusive health service for 101 years before the NHS came into being. It was healthcare ahead of its time, so much so that when Nye Bevan visited Swindon to see the health provision the MFS provided he famously commented: 'There it was. A complete health service in Swindon. All we had to do was expand it to the whole country.'

The notion of a national health service was tabled before the Second World War was won. A 1945 parliamentary white paper sketched the plan out. Yet, as Graham Carter writes in *Swindon Heritage* magazine, records unearthed at the Wiltshire and Swindon History Centre reveal involvement by the committee of the GWR Medical Fund. Then, February 1946 saw the convening of an English and Welsh Medical Alliances conference with Swindon chosen to host in what we now call the Health Hydro – though it remains known and well loved among older Swindonians as 'the Baths'. As Graham goes on to explain, it appears that representatives from that famous medical journal *The Lancet* were in attendance, if the mention of the Swindon's health service in its May 1946 edition is anything to go by. Outlining the town's services and facilities, it focused on the dispensary and the baths, rather than the cottage hospital, because they better fitted new ideas about the importance of wellbeing and prevention. In Swindon it found something special, something unique: 'it will be seen that the society provides for its members' needs from cradle to grave'; in the words of a distinguished medical visitor, 'The Medical Fund Society is the only current example in this country of an attempt to provide a comprehensive health service for its beneficiaries.'

Events Leading to the Formation of the Medical Fund Society

The year 1838 saw a partial opening of the line, at which point the company started a provident society, though the men in the Works weren't able to join it. They had to either pay the doctor or hope for kindness from him. By 1847 there were 1,800 men employed in the Works. At this stage, although the Mechanics' Institution, itself a few years older than the MFS, provided for the men's general welfare, nothing had yet been done about their health.

By 1847, the Works employed 1,800 men. At this stage, although the Mechanics' Institute, itself a few years older than the MFS, provided for the men's general welfare, nothing had yet been done about their health. To make the 1847 situation worse a need for economy forced a reduction in the number of men at the Works. During this and later similar times of crisis, some men left the town in hopes of finding work elsewhere while others stayed hoping for a reversal of fortunes. This particular crisis formed the catalyst for the creation of the MFS.

In the autumn of 1847, Daniel Gooch addressed a letter to the company secretary laying out the unhappy situation and pleading for it to be remedied. The image below shows an extract from the letter. Note that the men remaining in work are keen to support those without. This sense of themselves as a collective, as a body working together, is a spirit that underpins Swindon's heritage. The directors agreed and, within a month, in December 1847, the men still employed at the Works formed the GWR Medical Fund Society.

From that beginning there grew 'a body which cares for all those employed in the company's great railway works at Swindon and their dependents from the cradle to the grave.'

A Timeline of the Medical Fund Society

Autumn 1847: Gooch writes a beseeching letter to the directors of the GWR expressing the need for medical assistance. In December 1847 a medical society is formed.

My Dear Sir,

The serious distress that will be occasioned amongst our workmen at Swindon by discharging so many and putting the rest upon short time induces me to hope the Directors will grant a request the men have made to me, namely to assist the men to pay the Doctor for attending all the families of the men, both in and out of work, for the bulk of those discharged have determined to remain in the neighbourhood of Swindon in hopes of better times, as there is no chance of employment if they go elsewhere, and many have been very lately induced to come to Swindon at considerable expense to them in removing their families from a distance.

Those men who are to be retained in the Company's service have very generously offered to assist the unfortunate men in any way in their power, and one of the plans is to arrange with Mr. Rae, Surgeon, to attend the whole for a small weekly payment by each man. This arrangement I have no doubt I will be able to bring about if I can get some assistance from the Directors. What I would beg of them to do is to allow Mr. Rae to live in the Cottages house-free in consideration of his attending all the accidents that occur in the Works for nothing.

Extract from Gooch's letter to the company directors.

1853: a typhus outbreak befell New Swindon - the villain of the piece a contractor from Bath. Having undertaken to keep in good repair the company's houses in the new town as well as the bakehouse, the slaughterhouse and the drains, he'd done none of it. The MFS committee demanded that the company get a better water filter. They complained that the drainage in the village, such as it was, was in a bad state, with a lack of paving in general and no paving at all in the slaughterhouse. They asked for wells to be filled up because the privies leaked into them. Pigsties were a menace as were open drains. The privies were now discharging into the canal from which water was taken. Water MUST be better filtered.

1855: The society obtained its first invalid chair and there's the first mention of brushes for whitewashing. Four years later the society recorded on its books an official called 'The keeper of Lime, Brushes and Invalid Chair'. He had an allowance of £1 5s a year.

Late 1850s: The society first subscribed to hospitals in order to get letters allowing patients to be sent to them from Swindon. St George's, St Mary's and the Bath hospital were the first three.

1859: Mr G. M. Swinhoe was appointed doctor. He remained in post until his death in 1908 whereupon he was succeeded by his son Dr G. R. Swinhoe. Swinhoe Jr held office until 1917.

1860s: In modern times we take the provision in our homes of baths and showers for granted. Back then though, the adage of cleanliness being next to Godliness was not so well entrenched as it later became. So, all the more credit then to the society for inaugurating the first baths. The 1860 minutes record the granting of permission to put 'the shower and slipper bath' in the bath room at the Mechanics' Institution.

A year later came a project of much greater ambition: Turkish baths on ground behind the Mechanics' Institute. Three years on, in 1864, the baths were moved to the yard of the barracks, later a chapel and, later still, the first incarnation of Swindon's railway museum and now The Platform, a youth music venue.

In 1868, the new carriage and wagon works brought to New Swindon a huge influx of men – and therefore society members. As the society's prosperity grew the various baths acquired a title: 'a Bathing establishment for the company's servants. The 1869 society rules declared ownership of 'Washing, Turkish, Swimming and Shower Baths'. Not to mention an air bed and mattress and our old friends the lime and the brushes.

The 1860s then saw great strides. Come the start of the 1870s we find the society breaking new ground again. This time in deciding on a need for a hospital – for there was none of any kind in Swindon. As early as 1862, the committee recorded 'that an hospital in New Swindon will be beneficial to the inhabitants and members of the MFS, and that the secretary ask Mr Gooch and Mr Swinhoe to furnish particulars as to the formation and establishment of such a hospital'.

1872: The hospital, now Central Community Centre, on Faringdon Road, opened. The medical staff increased to two surgeons, Messrs Swinhoe and Howse, and two assistants.

The rules stated the hospital was for accidents only – not general diseases – and was to be free to all society members. Other servants of the GWR 'shall be charged a fair and reasonable sum for their maintenance as may be decided by the committee'.

1887: A dental clinic is set up and a dental surgeon appointed. By the end of that year he'd extracted over 2,000 teeth. That's a lot of tooth decay. Also in that year, an undertaker was added to the services offered.

The GWR
Medical Fund
Hospital.

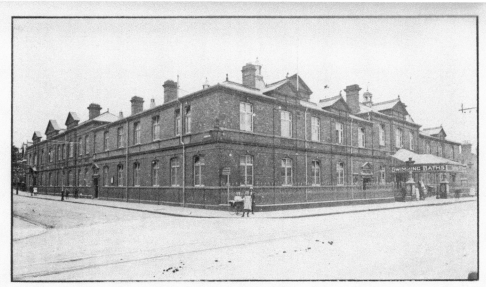

Dispensary and Baths

The Health Hydro, Milton Road Dispensary and Baths.

1892: A significant year. New consulting room, waiting halls, and a dispensary were opened, along with two new swimming baths – one small and one large. 1899 saw the addition of new washing, Turkish and Russian baths. In 2018 the Turkish baths are still going strong and are the oldest extant of their kind in the world. This building, the HQ of the GWR Medical Fund Society, is on Milton Road. It's now mostly known as the Health Hydro, though interchangeably as The Baths, Milton Road Baths or the Old Health Centre.

DID YOU KNOW?
The development of artificial limbs is due in no small part to the craftsmen of the GWR.

In 1878, an unfortunate chap called Harris had an altercation with a train that resulted in him having both his legs amputated. The society carved out a solution for him and gave him a pair of legs with sockets, something of a novelty then. Harris lived for many years becoming a familiar Swindon figure and going by the nickname 'Peggy Harris'.

He wasn't the only one to receive wooden replacement limbs, hands or feet. It was a common occurrence in the Works. You can see early examples of these limbs at STEAM Museum.

The world-famous Stoke Mandeville Hospital benefitted from the knowledge gained in the GWR works.

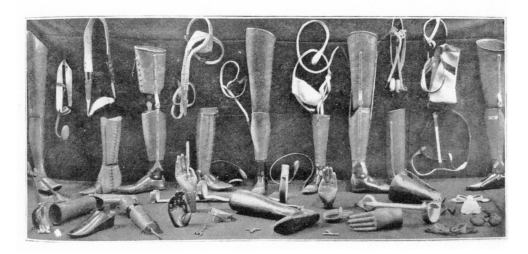

Artificial limbs developed by the men in the GWR Works. (Reproduced with permission from Local Studies, Swindon Libraries)

Payment for such a medical marvel came from subscription. Much as we now pay our National Insurance from our wages, these servants of the GWR Co. had their subscriptions to the MFS deducted at source. Swindon's GWR Medical Fund Society then was a pioneering venture well ahead of its time that played a significant role on both local and national stages. Thus, it's as worthy of celebration as anything you care to mention.

Park House

On the edge of the Railway Village, across from the GWR New Swindon Park, is Park House. Now the home of Business West and serviced offices, it was built for the GWR surgeons Messrs Swinhoe as a surgery and residence in 1877. By 1882 the population had already outgrown Park House and what it could offer. This need for bigger and better prompted the building of the first of the Baths and Medical Fund premises on Milton Road. Built in four phases, the complex was completed in 1906.

The Hooter Vexes a Viscount

For well over a century Swindonians' lives were ruled – whether their daily grind took place in the Works or elsewhere – with military precision by the GWR hooter. Hooty, as the locals nicknamed it, told them when to get up, when to set off to get to work on time, when it was lunchtime, when it was time to return after lunch and when their day's work was done. So, when the 5th Viscount Bolingbroke (of Lydiard House) attempted to silence the hooter, you'd think Swindonians would have been pleased. The Viscount complained that the hooter disturbed both his pheasants and his sleep and ordered its silence, an action that incurred the wrath of thousands of Swindonians and prompted a long petition calling for its reinstatement.

The GWR hooter still in situ on what is now the McArthur Glen Outlet Village.

Power to the People

William Morris (he of the *Swindon Advertiser* not the arts and crafts Morris) wrote in his book *Swindon Reminisces, Notes and Relics of Ye Olde Wiltshire Towne* what he describes as the 'all-supreme interests' of the landed gentry. In this commentary, he states, 'Perhaps the feeling ... was best of all exemplified in recent times by Lord Bolingbroke, when he set up some personal grievance of his own against the convenience of some five or six thousand working men...'

You'll recall Frederick Large's Swindon retrospect? On this event, he wrote, 'So bitter were the GWR employees and hundreds of others not employed in the Works, that a petition, miles in length (it was said at the time), was signed and sent to the proper quarter objecting to his Lordship's action, which had the desired effect.' Power to the people indeed!

Though silent now, you can still see the twin brass domes of the hooter close to the entrance of the Great Western Designer Outlet Centre.

DID YOU KNOW THAT?
Swindon new wave pop group XTC immortalised the hooter in their 1986 single 'The Meeting Place'. The song's inspiration came from the hooter and its distinctive tones form the song's introduction.

4. Aviation and Artistry Fly High in the Second World War Years – and Beyond

Those Magnificent Men in their Flying Machines

If the GWR steamed its way into Swindon's engineering history and automobile manufacture car-reered through it, then aviation flies loops in and around it. Swindon's aviation associations began with Richard Jefferies prophesying men making flying machines. Had he not died so young (aged thirty-nine from TB in 1887) he'd have witnessed the realisation of that notion. He might even have been among the crowd of awe-filled onlookers gathered to witness the first physical touchdown of Swindon's aviation associations when a Bleriot monoplane touched down on Swindon soil in July 1912. From that momentous event, the town's aviation story soared high during the Second World War with manufacturing connections with the Spitfire, the Seafire (naval version of the Spitfire) and the F21 to name some. So get your goggles on for a sortie through a selection of Swindon's many aviation connections starting with the Second World War.

Thanks to engineering skills honed in the GWR Works, the Second World War gave a flying start to Swindon's aircraft industry.

In 1938, when war appeared inevitable, good communication links and proximity to the skills of Swindon's GWR workers created ideal conditions for the selection of South Marston as a shadow factory site. The intention was for South Marston to shadow the Philips and Powis aircraft factory at Woodley, near Reading. In 1939 Philips and Powis Aircraft Ltd built a factory in Swindon to produce the Miles Master training aircraft. Over 1,000 planes, known as the South Marston Masters, were built there.

Much of Swindon's aircraft industry was, in the first instance, repair or component construction but soon Swindon began turning out the massive Short Stirling bomber, and, later in the war, the iconic Spitfire. Along with Seafires (the naval version of the Spitfire) Swindon's Supermarine factory produced Type 21 Spitfires with much of the work undertaken by the town's womenfolk.

Yet, as it turned out, South Marston's role in the Spitfire story was as short-lived as some of the planes themselves. In the end only 121 Mark 21s were built there, although the factory produced a further fifty Seafire planes. There was, though, some post-war production of later versions of the Spitfire. Completion of South Marston's last Spitfire – in fact a Seafire – was in January 1949. This interlude in Swindon's engineering history is, currently, modestly marked on what is now South Marston's Industrial Estate, on the site of the wartime factory. There you'll find an industrial building, a road and a café named for the iconic fighter plane.

The Spitfire
model on Spitfire
Way on the
South Marston
Industrial Estate.

The Spitfire Café.

Gaining altitude and cruising into modern times, (until 2011) the Lockheed c-130 Hercules, based at RAF Lynham, once graced Swindon's skies. As the site of repatriation of British personnel killed in Iraq and Afghanistan, RAF Lyneham earned the moniker 'the gateway' between the those two coutnries and the UK. The transportation route of the bodies passed through the nearby town of Wootton Bassett. The locals took to lining the street in tribute to each and every one. This recurring act of reverence earned the town the title Royal Wootton Bassett.

DID YOU KNOW?
Some Spitfire production moved to South Marston in Swindon after the bombing of Southampton's Supermarine factory. Come the 1950s, this factory formed part of the Vickers-Armstrong (Aircraft) Ltd, Supermarine Divison. Although the factory is now long gone, the Supermarine name lives on via two sports clubs. Both the Supermarine rugby and football clubs play on pitches that once formed part of the Vickers-Armstrong site.

Workers at Swindon's railway works made 171,000 components and carried out some timber airframe refurbishment for Hawker Hurricanes. At the same time, Marine Mountings at Wroughton, and Plessey, in Swindon, had involvement in producing components for the war effort.

One of Swindon's Spitfires, the LA198, forms the centrepiece of Glasgow's Kelvingrove Museum.

Swindon also has a long association with Concorde that took off with its first ever flight bringing the first prototype to nearby RAF Fairford. Concorde entered our airspace in 1969. There it became a familiar sight over Swindon's skies, as it landed and took-off almost every day during a five-year test programme before finally entering service in 1976. In that time, local companies played a huge part in its development. Both Vickers and Plessey were tasked with designing, manufacturing and engineering many of the parts and electronics needed.

We're Going to Make You a Starr

Swindon's aviation connections aren't limited to the flying machines themselves, but to the men who flew them too. 2015 marked the seventy-fifth anniversary of the Battle of Britain. That milestone gave Swindon the perfect moment to remember two of their own who were two of 'The Few'. I refer to the Starr brothers: Squadron Leader Harold Starr and his younger brother, Wing Commander Norman 'John' Starr.

Swindon's Battle of Britain commemorations centred around the elder of the two brothers, Harold. Sharing a birthday (though not a year – I'm not quite that old) with me, Harold came into the world on 8 September 1914, the fifth of six children. He grew up in Regent Street's Central Temperance Hotel. This is now the site of the Savoy pub and location of the blue plaques you see in the photo.

While still a schoolboy, Harold joined the Officers' Training Corps and won an RAF scholarship aged nineteen. Harold got his 'Wings' in 1935. Come 1936 his flying career almost crashed when he had an accident at South Marston in June of that year. Practicing a forced landing he crashed and the wing of his Hawker Audax damaged the gable end of a farmhouse. The farmhouse wasn't the only thing to sustain damage. Harold himself received severe injuries putting him out of flying action for over a year. Within two months of war breaking out, Harold was reaching for the skies once more and on 8 August 1940 Harold gained command of 253 Squadron.

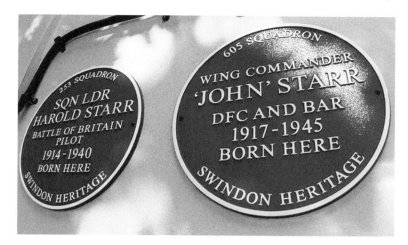

The blue plaques for the Starr brothers on the wall of what is now the Savoy pub and what was the Central Temperance Hotel. ('Swindon Heritage/Swindon Remembers')

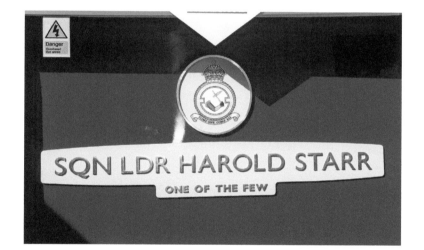

Harold Starr locomotive nameplate.

The Battle of Britain campaign diary shows that 31 August 1940 dawned fair but with a haze. By the end of that day, Fighter Command reported its heaviest losses to date. The list of names lost that day included twenty-five-year-old Squadron Leader Harold Starr. Shot down in his Hurricane over Estry, near Sandwich, during an interception patrol, Harold managed to bail out. Yet survival eluded him as three Messerschmitts circled him and killed him as he floated towards the ground. Two days before his twenty-sixth birthday, his body came back to Swindon for eternal rest in the family grave in Radnor Street cemetery.

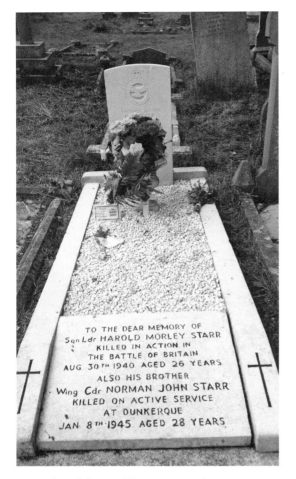

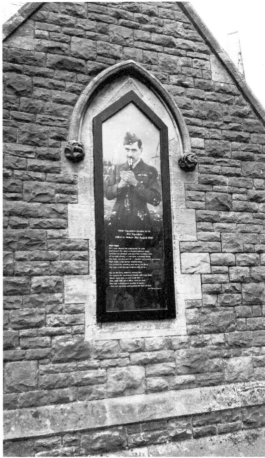

Above left: Harold's grave in Radnor Street cemetery.

Above right: Harold's window in Radnor Street cemetery.

DID YOU KNOW?

If you travel on the Great Western mainline you might well thunder up and down on the *Harold Starr* locomotive?

In September 2015, Prince Richard, Duke of Gloucester, unveiled a plaque and dedicated the Class 43 locomotive to Swindon's Battle of Britain Squadron Leader.

In 2015 Swindon honoured Harold Morley Starr's contribution to the war effort in spectacular style. Marking the culmination of a week's worth of activities and months and months of planning to celebrate the town's own Battle of Britain hero, Swindon was

treated to a flyover at Radnor Street cemetery by the Battle of Britain memorial flight. In the presence of the Duke of Gloucester, the distinctive engine sounds of Spitfires and Hurricanes filled Swindon's skies. In so honouring one of 'The Few', Swindon remembered them all.

Leslie Cole: Aviation and Artistry Combined

Whatever the merits or otherwise of today's art departments at Swindon's colleges, and I'm in no position to comment, there was a time when Swindon's old School of Art was a place with scale in its ambition. Out of that ambition came a phenomenal number of talented artists of all genres. Here I have space to mention but two that have passed through its doors: Ken White (more of him in Chapter Eight), and here, Leslie Cole.

Born in Swindon in 1910, Leslie Cole is noteworthy for his war artistry. Other artists used the war as their subject matter but Cole became an official war artist, one of only thirty in the country – something worth celebrating. The Cole family lived in Goddard Avenue, in Old Town, not so far from where Ken White lives now.

From Swindon art college, Cole progressed to London's Royal College of Art gaining a diploma in mural decoration, fabric printing and lithography before going into teaching art at Hull's art college in 1937. Then, in 1939, came the Second World War.

Sir Kenneth Clark, then director of Great Britain's National Gallery, launched a scheme to get the nation's artists involved in the war effort. The War Artist's Advisory Committee (WAAC) resulted and started recruiting. In 1940 a willing and able Cole applied, without success, for enlistment. So, instead, he followed fellow students into the RAF, though the start of the war saw him discharged on health grounds.

Yet the RAF's loss became the art world's gain. Cole now made a second attempt to become a war artist. This time around, his submitted examples of his figurative lithographs, reflecting both Swindon and Hull's war situations, found favour with the committee. The work he sent them included a 1941 painting showing a team assembling

Leslie Cole self-portrait. (Swindon Museum and Art Gallery)

Boy with Bird, Leslie Cole. (Swindon Museum and Art Gallery)

a landing craft, the setting for which may well have been the Swindon Works. He also painted women working on aircraft wings, again at a factory in the Swindon area. It's interesting to observe that Cole's pre-war paintings and drawings featured railway workers in Swindon, one of which is a lithograph of furnace workers in 1939. Ken White, on the other hand, began his working life inside before leaving to attend Swindon Art College, then turns his later hand to painting life as a Swindon railway man. This after many successful years as a muralist – something Cole also did.

With his talents recognised, Cole gained acceptance as a salaried worker with the commissioned rank of Captain (honorary) in the Royal Marines. He obtained permission to record the war effort at home and the damage Britain sustained from enemy action. In his determination to witness the events of the Second World War and to use his paintings to record them, Cole covered the theatres of war in Malta, Italy, Greece and Gibraltar. Following D-Day in 1944 he covered the Normandy offensive and later Burma and Singapore.

DID YOU KNOW?
Some of Britain's most important art collections include Cole's war paintings.

The Imperial War Museum in London holds twenty-five of his works, many of which he painted during his time in Malta. A further seventy are in private collections. Five, including scenes of Malta, are at the Government Art Collection, London. Three are at the National Maritime Museum, Greenwich, and there's one at the British Council.

Swindon Museum and Art Gallery has nine of Cole's paintings and lithographs in its collection.

Credited with an unflinching approach to his subject matter, Cole became one of four official artists selected to attend the first liberation of a major Nazi concentration camp. The images he produced are explicit and chilling. He captured in every detail the hellish conditions he saw, including the deaths of those for whom the Allied liberation was a fraction too late. A second commission with the Royal Marines command in Cairo came in 1944 followed by a transfer to the War Office.

Malcolm Yorke, in his book *The Artistry of Leslie Cole*, says that there was no expectation of war artists to be innovators of style or experimentalists, so British post-war art left Cole behind. Now there was Pop Art, Op Art, Kitchen Sink and Absent Impressionism. As Yorke argues, Cole must have felt marginalised and outmoded. Further, the war years had furnished him with urgent and often violent subject matter. They also provided deadlines, a WAAC patron, a steady income and no need to hustle for exhibitions. Is it any wonder then that with the loss of all that, combined with the changes in the art world and the horrors of what he'd seen, he became destabilised? This had been the time of his life and now he was adrift and losing momentum.

Post-war, Cole continued painting and teaching, though there's evidence to suggest that he struggled with his wartime experiences, a struggle that led him to drink heavily leading to a slow decline and an early death in 1976 aged only sixty-six. I fancy that the girl in the portrait *Mary, Young Girl with a Doll* is reflecting or echoing his mental struggles – she has such a melancholic look about her.

Nowadays, Swindon artist David Bent Hon CRAeS (he parachutes in again later in the book) keeps Swindon's relationship between art and aviation flying. David's aviation artistry is notable for, but not limited to, its connection to the Red Arrows. David's

Leslie Cole's painting *Mary, Young Girl with a Doll*.
(Swindon Museum and Art Gallery)

Above left: *Blitz* by David Bent. (Copyright David Bent)

Above right: David Bent: Spitfire and Hurricane Ad Astra from David's Tribute 100 collection, marking the centenary of the RAF and launched at the National Memorial Arboretum in April 2018. (Copyright David Bent)

brushwork has formed images of many aircraft and some scenes of the Second World War, including the Blitz and the Battle of Britain.

Leslie Cole's Alternative History

Nothing to do with his art and everything to do with salacious gossip is the saucy story of Leslie Cole's wife, Brenda Harvey (real name Barbara Price).

Some years before Cole married his bride in August 1938, Harvey/Price was the star witness in a sex scandal in which one Harold Davidson, the rector of Stiffkey (an appropriate name if ever there was one), a sleepy Norfolk coastal village, stood accused of immorality. The Bishop of Norfolk accused him of liaison with prostitutes in London's Soho, behaviour for which he was found guilty and subsequently defrocked.

In her pre-marital life as Barbara Price, Cole's wife instigated the trial by sending the bishop a fourteen-page letter full of 'helpful' details. She gave evidence for three days then disappeared, to resurface as Brenda Harvey when she met and married our man Cole.

As for the transgressing rector, he came to a suitably sticky end. Sounding like a stanza from Stanley Holloway's *Albert and the Lion*, the poor unfortunate ex-clergyman suffered a fatal mauling by a lion in a Skegness fairground.

Now for some time travel and a leap forward to Swindon's more recent cultural past.

5. Looking to the Future: The Western Expansion and Public Art

A Plethora of Public Art

I've no idea how much public art other towns have but it seems to me that Swindon has an astonishing amount. When I began blogging about Swindon, the public art was one of the first things I turned my keyboard to. Not that I even knew the term then. Back in the corner of Derbyshire I left behind, the closest I got to it was an ancient village pump, a cenotaph and a redundant and rusting pit-winding wheel. Hence, discovering all the public art in Swindon was quite the revelation. It's not possible to write about all of it here but, if you're so inclined, Born Again Swindonian has oodles of posts about Swindon's public art – in particular the West Swindon sculpture trail.

The Western Expansion and the West Swindon Sculpture Trail

I mentioned earlier that I live on the west side of town in the western expansion. Begun in the 1970s, this extensive and surprisingly green suburban area links the town with the M4, which opened in 1971. Following boundary changes two years later, the borough of Swindon merged with the adjacent Highworth Rural District to become the borough of Thamesdown.

Westward with the Silver Book

In the 1960s thoughts of Swindon's expansion turned westwards. Much as now, central government concerned itself with the need for housing for a growing population. With this in mind, they commissioned a study to look at a new city in West Berkshire/North Wiltshire. In the end, Swindon rather than Newbury was chosen for expansion.

With Swindon identified, planners from Swindon, Wiltshire County and Greater London produced a report in 1968. Known as the Silver Book for its shiny cover, this report set out how and where such growth might happen. In the 1980s Swindon expanded westwards with Toothill and Freshbrook being the first to form the area now known as West Swindon. This area saw the first out-of-town shopping centre in Swindon with a Carrefour (now Asda) supermarket as its lynchpin.

Forming an intriguing punctuation to this conurbation is a diverse collection of sculptures that comprise the West Swindon Sculpture Trail. Installed between 1982 and 1992, these fascinating sculptures are unexplained and often unnoticed by Swindonians. Looking somewhat neglected and forlorn these days, though nonetheless interesting for thier neglected state, they encompass a gamut of subject matter that ranges from realism to abstract with a film star and a nursery rhyme in the mix. The incumbent Thamesdown Borough Council commissioned these sculptures with contributions from the developers

The Silver Book: *A Study For Further Expansion.*

under the Percent-for-Art in the public realm scheme. At the time of their installation they were not designed as an entity. Roger Ogle, a Swindon resident and creator of *Swindon Link* magazine, mapped out a 5-mile circular walk taking in all the sculptures and the West Swindon Sculpture Trail became a thing.

Looking to the Future

It is a fitting title for an artwork designed and installed at a time of new growth in Swindon. Created in 1985 by Jon Buck, West Swindon's first artist in residence, this sculpture features three fibreglass figures in bathing suits, though the bathing suits have pretty much weathered away by now – some restoration work is needed.

DID YOU KNOW?
One of the sculptures in West Swindon is a larger-than-life representation of the actress Diana Dors, a famous daughter of Swindon. Film-maker David Putnam unveiled the sculpture in the early 1980s.

Jasper Fforde set his Thursday Next books in an alternative Swindon in which he created Seven Wonders of Swindon. One of Fforde's seven wonders is a towering sculpture of a film star named Lola Vavoom. This 'wonder' is clearly modelled on the Diana Dors sculpture but is located elsewhere in the town and is a whole lot taller than its muse.

Thanks to the efforts of the Swindon Heritage group, a blue plaque commemorates the location of the nursing home where she entered the World as Diana Fluck.

The *Blondinis*

I miss the *Blondinis*. The *Blondinis* is a sculpture of two members of an acrobatic family who often performed in Swindon. It used to reside in Wharf Green in the town centre, and I loved it. I loved its exuberant colours. It didn't half brighten up a dull day – and goodness only knows we get enough of those! When Wharf Green was refreshed the

Above left: Diana Dors in silhouette at the Shaw Ridge Cinema complex in West Swindon.

Above right: Artist Tim Carroll at work restoring the *Blondinis*. (Photo credit Gordon Dickinson)

Right: The *Blondinis* as painted by Tim Carroll in his *One Hundred Views of Swindon.*

Blondinis disappeared before a getting a much-needed makeover from Swindon artist Tim Carroll in 2009. As fortune had it, the specialist aluminium paint needed for this restoration task happened to be available at a local paint supplier, Holman Specialist paints, who did all they could to support the restoration project. Following removal from their town centre home the poor *Blondinis* ended up lying at a council storage site. In a ten-day timeframe, Tim rubbed down and repainted the pair ready for their move to their new home in St Mark's Park, Gorse Hill.

Being somewhat garish they're not everyone's cup of tea I know. What's more they're imposing at 17 feet tall. John Clinch created the sculpture in 1987 (he also created *Diana Dors*) using scraps of aluminium from Swindon's railway works. Commissioned by the then Thamesdown Borough Council with financial assistance from Sun Alliance Insurance Group, Southern Arts, British Alcan and Metalfast Ltd, this piece was the absolute last thing to be cast in the once great GWR Works, which imbues them with some significance.

The *Wish Hounds*

If you ask me, all the public art pieces in Swindon have their own charms but this piece is one of my favourites. It's not a piece I get to see much, tucked away as they are not on the way to anywhere, but I find them haunting.

In Cornwall there's a tradition of a midnight hunter and his headless hounds. I've no idea if this slice of mythology and folklore inspired Swindon's fantastical sculpture or not but they're intriguing for sure. Created in 1994 by Lou Hamilton, they have a menacing air about them on the most pleasant of days, though I suspect dusk is the best time of day to appreciate this artwork. If you dare...

I'm informed by a reader of Born Again Swindonian that the *Wish Hounds* are on such long legs because they were originally intended to appear above the tree line to drivers on the M4. Apparently, they looked magnificent, appearing to leap over the trees. Indeed, there are (now mostly broken) spotlights around the sculpture so they must have been floodlit. The thing with trees is that they grow and now they obscure the *Wish Hounds* from the road. Hence, unless you're going to Croft Wood, near the Nationwide HQ, you won't see them. It's barking mad!

The *Wish Hounds* by Lou Hamilton, 1994.

Public Art of the Bovine Variety: It's All Moos to Me

Whenever I see this 1987 cow sculpture it makes me smile and think of one of my favourite Ogden Nash poems:

> Two cows, mildly mooing:
> No bull; nothing doing.

If you think about it, that is a masterclass in understatement. As is:

> The cow is of the bovine ilk;
> One end is moo, the other milk.

Anyway, I simply like that it's there. Why a cow in particular I don't know. Though it now chews the cud in solitude at the Great Western Hospital, it used to be at the old Princess Margaret Hospital in Old Town. So perhaps it was another subtle reference to the existence of the livestock market in Old Town days of yore? We've got a sheep and a cow. We're only a pig short of a farmyard.

The cow at the Great Western Hospital.

Angel Ridge: Part Play Park, Part Public Art

You'll find the Angel Ridge play area on the site of Swindon's original NHS hospital, Princess Margaret Hospital, now redeveloped as a residential housing site. Taking inspiration from the ichthyosaur of *Blue Peter* fame, this lovely play park features fossils throughout and with hidden replica fossils hidden in the sand area. A giant ammonite heralds the play site's start.

One of the key features of the site is the weighty Turning Stone, a huge 5-ton boulder that even small children can rotate with ease. A poem by Jane Evans is inscribed on the stone and sums up the overarching themes of the scheme.

Swindon's Icthyosaur represented at Angel Ridge play park.

Cambria Bridge Mural

In a neat bit of artistic symmetry Ken White, well known for his murals in Swindon, London and the world, now features in a mural down on Cambria Bridge. On that location there once was a very different mural painted by Ken himself.

Two hundred feet long, the new mural depicts people, buildings and entities key to the town. They're linked together by an old-style police box at one end and the *Doctor Who* TARDIS at the other. Fittingly the mural features Billie Piper who played *Doctor Who* companion Rose Tyler and who hails from Swindon. It also features Swindon's suffragette, Edith New, community arts projects the Octobus Project and Swindon Viewpoint, Britain's original community TV service. Viewpoint began in 1973 and now boasts a vast quantity of archive and contemporary material on its website.

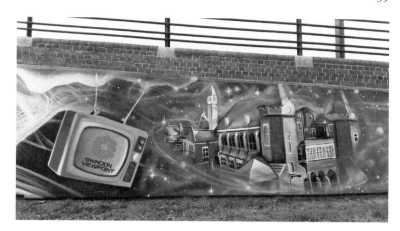

Section of Cambria
Bridge mural
referencing
Swindon Viewpoint
and the GWR
Barracks – now
The Platform.

Old Town Railway Path

Back in 1980 a Swindon bike group saved a disused railway line running along Swindon's
southern flank from development. They offered to construct a path for walking and
cycling. Yet it took until the mid-1990s for the bike group to get an opportunity to get
creative with the path. Placed at intervals along the route is what I can only describe as
an art installation. It comprises five wheels, from the Old Town direction towards the
railway and Wootton Bassett Road marked Earth, Air, Fire, Water and Conceive. There are
two parts to each wheel: a small wheel showing the element and a large wheel bearing a
short poem. In addition, lengths of wood cross the path between each wheel pair. They too
have words inscribed on them. Muck, mould and graffiti obscure some of the wording,
yet what is discernible is strangely haunting I must say.

Stones/wheels/
sleepers on old
town railway path:
Disquiet.

Kiln Park: Clay Tiles Round a Tree

My regular walk to the West Swindon Centre takes me alongside an open green space bordered by Grange Park, Westlea and Freshbrook. On this green space there is a tree. Once upon a time the tree was encircled by a bench but that's now long gone. What does still circle it though are decorative clay tiles. Interspersed with patterned tiles, they spell out the message: 'Kiln Park. 150 AD–1989'.

You'll recall from the settlement whose name sounds like a cough mixture that there once was a large Roman presence in the area. The place that we know as Swindon lies on the junction of two Roman roads: one leading south from Cirencester towards Marlborough, and the other, Ermin Street, went eastwards to Silchester. In West Swindon the Romans ran a large pottery industry. Evidence suggests that our Roman invaders quarried stone for their villas and that they used clay from the Whitehill region – now West Swindon – to produce Whitehill Ware pottery. Hence we have Kiln Park.

A Round of Applause

After that whistle-stop tour of some of Swindon's public art put your hands together for a round of applause. What better way to do that than with this handy (see what I did there?) sculpture entitled ... wait for it ... *Applause*! Created by Martin Amis and dated 2003, this super sculpture has an appropriate location outside the Arts Centre in Old Town.

Applause: a large sculpture of hands clapping outside the Arts Centre in Old Town.

6. Iconic Architecture and 'a Great Deal of Building'

In 1950, Swindon's council published *Studies in the History of Swindon*, a volume that contains a contribution from the poet John Betjeman. In his contribution Betjeman made the observation that: 'There is very little architecture in Swindon but a great deal of building.' He then went on to comment that, 'Swindon, instead of being a West Country town, looked on its outskirts at any rate, like any industrial town anywhere.' Now, I could be mistaken, but I think there's an implied sadness there due to Swindon's location. There's surely no reason though why, by sheer dint of its position rubbing shoulders with Bristol and Bath and Cheltenham, Swindon should be similar in architectural terms? It's an industrial town after all. Isn't that rather the point? Those three places grew out of very different circumstances to Swindon. 'Let's go to Swindon for a spa break', said no one ever. Whereas 'let's go to Swindon for jobs and economic prosperity', said thousands. It was the great GWR industry that brought New Swindon into being and it's industry that has breathed life into its lungs ever since. So why would the town have sweeping Georgian crescents or Regency arcades?

Betjeman made that observation two decades or more before Swindon gained the modern buildings that are loved or loathed in equal measure. At least, as Graham Carter (editor of *Swindon Heritage* magazine) is oft heard to utter, they're designed by people you've heard of: Sir Norman Foster and Sir Hugh Casson, responsible for the Spectrum Building (still known to many as the Renault Building despite Renault being long gone from it) and the Wyvern Theatre respectively.

Betjeman was a lover of, and passionate advocate for, Victorian architecture. Thank goodness for that. Otherwise the nation and the world would have lost the glory that is Gilbert Scott Thomas' St Pancras station in London and other edifices saved by Betjemen. We also have him to thank for the continued existence of our Railway Village. As a 2017 article from the *Swindon Advertiser* points out, the 1960s saw plans to raze the area. Only a campaign by Betjeman saved it. It's a moot point though whether he would have approved of the Wyvern Theatre, the Link Centre and Foster's Spectrum building. Tension structures such as the latter two are of their time. Be that as it may, they have architectural interest if not merit – not that I'm any arbiter of that – and none more so than my particular favourite: the David Murray John Tower.

The David Murray John Tower: Modernist Lines on the Swindon Skyline

Often referred to as the Brunel Tower due to its location in the Brunel Centre, this behemoth of a building is in fact named after David Murray John, clerk of Swindon Borough Council from 1938 to 1974. The efforts of this energetic politician contributed, in no small part, to the influx of small industry into Swindon following the Second World War.

The Wyvern Theatre by Sir Hugh Casson. (Chris Eley)

The Link Centre in West Swindon. (Chris Eley)

The David Murray John Tower (DMJ) is an exuberant exclamation mark of a building that proudly proclaims itself across the Swindon skyline. At 83 metres high, the DMJ (along with Old Swindon's Christ Church) is the master of all it surveys. The building struck me when I first moved to Swindon and I love it to this day.

Knowing even less at that time about architecture than I do now (which is not to say a great deal) it seemed to me to have something of a futuristic feel to it – though I couldn't pin it to anything more specific than that. It's only now, having researched the building a little, I understand what my subconscious was relating to. Now, before you say it, yes, I *know* buildings – and this one in particular – are hardly a secret. Their physical presence rather precludes that. So no, the *fact* of them isn't secret, but it's possible that things *about* them are. Like this for instance...

The David Murray John Tower. (Chris Eley)

Douglas Stephen

The architect responsible for the DMJ Tower was Douglas Stephen. Stephen is now dead, though his name lives on in the Douglas Stephen Partnership. If your response to that nugget of information is 'Douglas who?' you would be in good company. Back in 2004, Jonathan Meades (essayist, broadcaster and architecture writer) published an article on Building.co.uk entitled 'Five great architects ... you've never heard of', in which he writes about a number of architects, Douglas Stephen included, on why they're so good – and also so neglected. On the subject of Stephen, Meades has this to say:

> Yet there was something about the details ... The Mount was the first of Douglas Stephen's buildings I saw. It was completed in 1965 and was entirely out of step with its time: it was at odds with both the fey Festival style and with the sculptural brutalism that was the conventional reaction to the Festival style (and which Stephen had essayed). But Stephen belonged to no school. That, I suspect, is why he is overlooked. The Mount retains its extraordinary freshness. So does his David Murray John Tower in Swindon, that town's most (only?) striking building, a mini-skyscraper that has affinities to a design of Frank Hampson's for Dan Dare, Pilot Of The Future.

I think now that it was the Dan Dare influence that whispered to me when first my eyes alighted upon the DMJ tower. As to whether Stephen's building achieved that lofty aim I'm not sure. Its intended mixed-use was innovative in its day, but it's arguable that it turned not to be so workable in practice.

Looking to the Future

The intention of the building's futuristic look was to reflect the forward-looking aspirations of the town at the time. With its curved corners, the design of the building is sleek and sophisticated. It's clad in stainless steel – an expensive material even then. It makes historical references with its nods to art deco and modernism. Everything about the building makes a statement – it screams at you to look it. Indeed, you can't avoid looking at it: it's visible for miles. A landlocked lighthouse at night.

A Wonder of Swindon

Mr Meades isn't the only one to find favour with the David Murray John Tower. When talking about this building I should mention that the author Jasper FForde famously invented 'The Seven Wonders of Swindon'. Taking the top spot on his list is the Tower of Brunel. In Fforde's books, he has the city elder Mr David Murray John requesting a tower to touch the sky. Something to give Swindon a skyline such as it had before the five-centuries-earlier destruction of the Cathedral of St Zvlkx.

Okay, the real Tower of Brunel doesn't quite reach the vertigo-inducing heights of Mr Fforde's invention but a skyline it does give. Yes, there's an argument that the architect's intentions didn't quite come to fruition. Yet there's much around this edifice to laud and applaud. There's Murray John's energetic exhortation for a tower to touch the sky. There's the shining optimism it was built to represent and Fforde's tongue-in-cheek yet affectionate tribute.

Perhaps above all though, is the singular fact that Jonathan Meades, a respected authority on architecture, placed the DMJ on his personal list of five extraordinary buildings in the world. Keeping company with Marseille Cathedral, the Walhalla Temple in Bavaria, Cothay Manor in Somerset and Edinburgh's Stewart's Melville College.

DID YOU KNOW?
Back in 2012, Meades wrote an article for *The Telegraph* about his five favourite buildings in the world. The David Murray John Tower is on that list. He wrote of it:

Designed by Douglas Stephen and built in the Seventies, this tower is a sleek, slick return to the smooth white grace of Twenties and Thirties Modernism. It's a mixed-use building, incorporating social housing, offices and retail, which is rare in Britain. Stephen was a communist and believed in architecture as a power for social good.

On the Spectrum

My second favourite building in Swindon, the David Murray John Tower being my number one, has to be the Spectrum Building, or the Renault Building as it's often still referred to. Built in 1981–82 as a warehouse and distribution centre for vehicle components for the Renault car company, it's the creation of Sir Norman Foster.

Demonstrating that the listing of buildings isn't all about old buildings, the Spectrum building achieved Grade II-listed status in 2013.

Once completed, the Renault Centre received widespread admiration winning several awards. Madam La Lumiere, the then French Secretary of State for Consumer Affairs, performed the official opening on 15 June 1983.

DID YOU KNOW?
In 1985, the Spectrum Building featured in the James Bond film *A View to a Kill*. Not the only Swindon building to attract producers of Bond films, the Motorola building has also enjoyed that privilege.

Other Buildings of Interest

The DMJ and the Spectrum Building might be my personal favourites but that's not to say that there aren't other interesting buildings. Here's a round-up of a few:

Art Deco Building on Regent Circus
Built in 1933 as Swindon Corporation's electricity showroom, this art deco building now houses Rudi's wine bar and restaurant.

Vilett's House in Old Swindon
Betjeman refers to No. 42 Cricklade Street, built in 1729, thus: 'The first architecture to appear in Swindon, that is to say the first conscious designing of a façade ... is one of the most distinguished town houses in Wiltshire.' Indeed, the front of the house bears a plaque proclaiming that very thing!

Villett's House, No. 42 Cricklade Street, Old Town.

The Town Hall
Now the home of Swindon Dance, New Swindon's town hall, designed by Quaker architect Brightwen Binyon, had its foundation stone laid in 1890 and was declared open by the Marquess of Bath in 1891. Similar to neo-seventeenth-century Dutch architecture it's two storeys high. The building boasts a 90-foot clock tower above its west front. Beneath that the main entrance porch faces Regent Street.

In keeping with the idea of things hidden in plain sight are the railings running around the town hall. They are gorgeous and qualify as public art in their own right. Yet I managed not to notice them for years and I suspect the same is true for many. Designed to detail hand

Brightwen Binyon's New Swindon Town Hall, 1891.

Close up of the Town Hall railings forged by Avril Wilson.

gestures and dance movements and installed in 1997, the railings are the work of Avril Wilson. Avril is the first female artist-blacksmith to receive a bronze medal from the Worshipful Company of Blacksmiths to recognise her contribution to architectural metalwork.

At least as interesting as the building itself are two things inside it which, unless you are part of Swindon Dance or have been to an event in the building, are secret Swindon for sure. One is a mural painted by Swindon-born artist Carleton Attwood. Also a sculptor, Carleton created both the Golden Lion that sits purring to itself in the town centre, and *The Watchers,* one of the sculptures over in West Swindon. The other, sitting minding her own business in the lobby of the Town Hall, is a statue of Charlotte Corday, who is famous for stabbing to death Jean-Paul Marat in 1793. In the 1860s Pasquale Miglioretti created at least three versions of the *Angel of Assassination,* one of which found its way to Swindon! How marbleous is that?

Arclite House in West Swindon

Reminiscent of a Zeppelin, this building is often referred to as the glass cigar. This building won the Best Large Office award at the 2000 design awards run by *FX* magazine's international interior design awards. Once the home of Cellular Operations HQ and later Vodafone's consumer arm, Arclite currently offers a window over Peatmoor lagoon to Excalibur Communications and the Positive Media group.

Arclite House in Peatmoor, West Swindon. (Chis Eley)

Prospect Terrace, Old Town

To prove, as if proof were needed, that Swindon can always surprise, I saw this eight-house terrace for the first time only recently. Probably designed by local architect Sampson Sage, the houses are built in a rustic Old English style from local sandstone and given a rock-like appearance. The houses have Bath stone dressings. Dated 1845–46, they're the earliest example in Swindon of this sort of architecture. Once a designated listed building, the terrace now has a demotion to conservation area status.

Prospect Terrace in Old Town. (Chris Eley)

7. Up the Junction with the Magic Roundabout

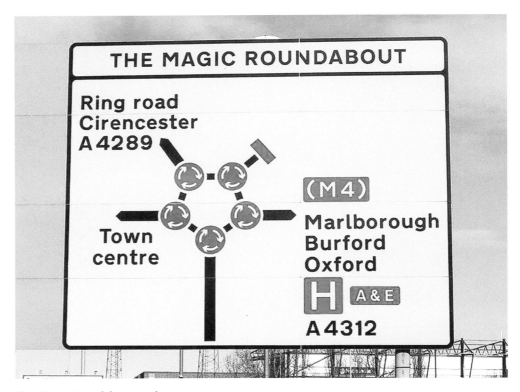

The Magic Roundabout road sign.

Though a non-driver I hold a great deal of fondness for the Magic Roundabout. During recent English degree studies (I graduated in 2014) I undertook a travel-writing module, 'Moving Words'. Taking that module played no small part in my setting up my Born Again Swindonian. Inspired by the words of Professor Jarvis, the module leader, I decided to use Swindon as source material for my portfolio of travel pieces. One of the pieces I submitted was a guidebook entry about the Magic Roundabout, the premise being that it was for inclusion in an imaginary rough-guide to Swindon. I acquired a first for that piece of work, for the module and for the degree as a whole. So you can see why I'm so fond of it?

Yes, you can argue that this stupendous piece of traffic management doesn't quite match the accepted definition of 'secret'. I get it. It's well known across the pond where it invokes a mixture of amusement, bafflement and fear. Indeed, a cursory Google search for the thing will find YouTube clips with such irresistible click-bait titles as 'See how an

The Magic
Roundabout
in mosaic
form by
Lynette
Thomas.

insane seven-circle roundabout actually works'. Yet, for the most part, Swindonians take it in their stride. The thing is though, it's Swindon's unofficial logo – and it looms large in Swindonian's lives in every way. Go to the main desk in the central library and you'll find t-shirts, mugs, key rings and postcards all honouring this celebrated road junction. It's even reflected in art as in this piece by a local mosaic artist Lynette Thomas.

Furthermore, unless and until Swindon gets a theme park, it's the closest you'll get here to a white-knuckle ride – well, perhaps the No. 1 bus when the driver is running late. If there's a kerb to be hit...

A flick through the August/September 1972 edition of *Civic News* reveals a great feature about the junction. Our American cousins might well benefit from this instructional diagram on 'The Correct Way through the Junction':

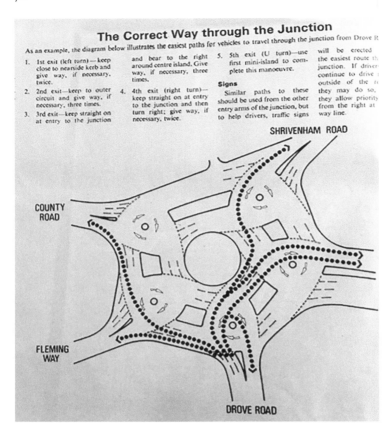

The Correct Way through the Junction

As an example, the diagram below illustrates the easiest paths for vehicles to travel through the junction from Drove R

1. 1st exit (left turn) — keep close to nearside kerb and give way, if necessary, twice.

2. 2nd exit — keep to outer circuit and give way, if necessary, three times.

3. 3rd exit — keep straight on at entry to the junction

and bear to the right around centre island. Give way, if necessary, three times.

4. 4th exit (right turn) — keep straight on at entry to the junction and then turn right; give way, if necessary, twice.

5. 5th exit (U turn) — use first mini-island to complete this manoeuvre.

Signs

Similar paths to these should be used from the other entry arms of the junction, but to help drivers, traffic signs

will be erected the easiest route th junction. If driver continue to drive outside of the r they may do so, they allow priority from the right at way line.

Diagram from a 1972 *Civic News* showing how to travel through the junction. (Reproduced with permission from Local Studies, Swindon Libraries)

It also features a wonderful black and white photograph of a 3D model of the roundabout:

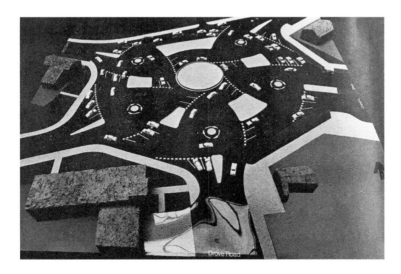

Model of the Magic Roundabout from the 1972 *Civic News*. (Reproduced with permission from Local Studies, Swindon Libraries)

While for lovers of statistics and numbers there are these 'Facts and Figures of the Junction'. The total cost came out at £65,000, a sum that would struggle to buy a garage for one car these days let alone pay for a roundabout full of them.

Facts and Figures of the Junction

TOTAL COSTS: £65,000 divided as follows:

Department of Environment	£37,500
Transport and Road Research Laboratory ..	£15,000
Wilts. County Council	£6,250
Swindon Borough Council	£6,250
	£65,000

The £15,000 allocated by the T.R.R.L. represents additional civil engineering costs required for the ring junction.

Lighting. A new 30 metre (100ft.) high mast lighting column is to be erected in the centre of the junction. It will carry 10 lanterns of 400w each, high pressure sodium.

The existing street lamps around the perimeter of the junction will be replaced by 12 metre (40ft.) high columns carrying 1 lantern of 250w each, high pressure sodium.

Road Surface. A temporary road surface will be used for the experimental stage of the works. The final road surface will not be laid until after the completion of the experiment.

Islands. The experimental islands will be constructed of old car tyres painted white.

Traffic Information

Year	Vehicles per week	Passenger car units per peak hour*	
1958	Not known	1,850	5 p.m.—6 p.m.
1964	200,000	—	
1965	209,000	3,610	4·30 p.m.—5·30 p.m.
1966	246,000	—	
1967	249,000	—	
1968	259,000	4,571	4·30 p.m.—5·30 p.m.
1969	270,000	—	
1970	281,000	—	
1971	286,000	4,574	5 p.m.—6 p.m.
1972		4,832	4·30 p.m.—5·30 p.m.

*Passenger car units are equated as follows:
Three bicycles—1 p.c.u.
Three motor cyclists—2 p.c.u.
A car or van—1 p.c.u.
A lorry—1½ p.c.u.
A bus or coach—2½ p.c.u.

Road Accidents

Year	Total Accidents	Persons Injured
1963	20	3
1964	11	5
1965	15	9
1966	26	8
1967	29	6
1968	24	11
1969	32	8
1970	40	15
1971	39	11
1972 (6 months)	20	4

Published by Swindon Borough Council, Euclid Street, Swindon.

Newspaper clipping showing some facts and figures of the junction. (Reproduced with permission from Local Studies, Swindon Libraries)

SWINDON RING JUNCTION EXPERIMENT

A new experimental roundabout is being constructed to replace that in Drove Road. The junction is a focal point of Swindon's main road system and the congestion now occurring at peak traffic times has caused the Council to consider various methods to overcome the problem. Since the roundabout was opened in 1960, the number of vehicles using it has increased from under 200,000 to nearly 300,000. The number of people injured per year in road accidents has increased from 3 to 11. The Council have decided that the junction must be made both safer and able to handle a greater flow of traffic.

Two conventional methods were open to the Council. One was to replace the large roundabout with a small one, giving wide road surface area. The other was to build a flyover or a series of flyovers. Both ideas were rejected. The first, because of the likelihood of an increase in the accident rate, the second, because of the cost (over £500,000), appearance and the necessary property demolition in the area.

New Junction Design

The Transport and Road Research Laboratory have recently carried out experiments on their track at Crowthorne, on a new type of junction design incorporating a series of mini roundabouts. These experiments proved capable of substantially increasing traffic flow. Swindon Corporation have, therefore, agreed to co-operate with the T.R.R.L. in carrying out an experiment to test the new idea on public roads.

The scheme approved by the Corporation involves a multi-mini roundabout scheme, on an experimental basis. This gives a real prospect of creating a safer junction with a much higher traffic capacity. If it is successful, of course, it

causes other drivers to wait longer than necessary at the entry points.

Give Way!

At the new junction it will be necessary for drivers to travel more slowly because they must be prepared to give-way 2 or 3 times. The junction capacity will further be increased if as many vehicles as possible cross the give-way line during each gap in the traffic streams approaching from the right.

could be of immense advantage to highway and traffic engineering nationally.

Three Stages

The first stage of the experiment has already begun. This is the detailed measurement and photography of traffic conditions with the existing roundabout.

Stage Two will be to install a small conventional roundabout, again measure and photograph traffic conditions, and determine the most practical size for such a single roundabout which would increase the capacity of the junction.

The third stage will be the installation of the ring junction design, shown in the diagram, with traffic being measured and photographed again. The shape and position of the various islands and white lines will be changed during the experiment, in order to determine the best layout for Swindon's conditions.

Advice to Drivers

A major cause of congestion on the existing roundabout is that many drivers travel at fast speeds (more than 15 m.p.h.) through it, which

To help you

The following points will help you to use the junction in safety, and with least delay.

1. Queue alongside one another rather than behind one another, at give-way lines.

2. On approach, use the lane with the shortest queue which is convenient for your exit.

3. At entry be ready to make prompt use of any gap which may occur.

4. Enter the junction when you can do so without causing vehicles from the right to stop, swerve or brake sharply.

5. Always give way to the vehicle on your immediate right.

6. If, when circulating, another vehicle crosses the

give-way line in front of you, drive to pass behind rather than in front of it.

7. Always signal right and left turns. This helps other drivers.

8. You are advised to use dipped headlights at night.

9. WATCH OUT FOR GIVE-WAY LINES

We hope that all drivers will co-operate with the experimental scheme, which is designed for their benefit.

Extract from *Civic News* article on Swindon's Ring Junction experiment. (Reproduced with permission from Local Studies, Swindon Libraries)

The Magic Roundabout is an excellent metaphor for Swindon. As I've heard Graham Carter comment more than once: 'It's ingenious and it works.' He's not wrong. Now, for the craic, and for anyone reading this who *isn't* familiar with the Magic Roundabout, here is the guidebook entry as I wrote it for my degree course.

Dare you navigate yourself across the infamous & world-famous counter-flow 'Magic-Roundabout' – the 'white-knuckle' ride of traffic?

You'd be forgiven for being perplexed at the notion of a traffic roundabout being of any interest to anyone other than traffic-system aficionados, but you couldn't be more wrong. This fabled entity is known the world over.

Created in 1972, Swindon's Magic Roundabout was originally named the County Islands Roundabout due to its location in close proximity to the town's County Ground

football stadium, home of Swindon Town FC. However, the locals were not long in bestowing upon it the nickname 'The Magic Roundabout' after the TV programme of that name. Eventually the local authority submitted to the popular consensus and officially renamed the roundabout and gave it appropriate signage.

Swindon is famous, even infamous, for its roundabouts, but this legendary one surely has to be the jewel in the town's roundabout crown? Situated on a junction where five roads meet, the traffic-consuming monster vexes native visitors and utterly baffles those from across the pond. For all this, though, Swindonians love it and generally find their passage across it to be smooth and fluid, even at peak times.

The roundabout was created by the Road Research Laboratory (RRL) to deal with an area that was a motorist's nightmare, being routinely unable to handle the sheer volume of traffic converging on it from five directions. Like many of the best ideas, their solution was stunning in its simplicity. They simply combined two roundabouts in one. The first is the conventional clockwise type and the second, revolving inside the first, sent traffic anti-clockwise. This counter-flow roundabout solved the congestion problems back in the 1970s and is still, despite the ensuing increase in traffic volume over the last forty years, processing it all as quickly and as smoothly as a giant Magimix.

Traffic keeps moving almost all the time, waiting only a few seconds to join each mini-roundabout and thus steadily travelling at low speed across the junction. A normal roundabout would involve long waits to join; signals would involve bursts of movement and long enforced stoppages. As a result, it has been calculated that the Magic Roundabout has a greater throughput of traffic than anything else that it would be possible to install in the same space Magic indeed! Moreover, it has an excellent safety record.

Although voted the seventh worst junction in the UK, the roundabout's bark is worse than its bite. Though appearing difficult to negotiate, all it asks of the driver is to be observant and to always give priority to traffic coming from the right.

One approach to the roundabout is to drive down Drove Road from Swindon's Old Town. If you don't fancy manoeuvring it in a car it's possible to stand and observe the carefully controlled mayhem from the safety of the pavement – you can even consume fish and chips from the Frying Fish chippy on the corner while you do.

Swindonians are very proud of their Magic Roundabout and the tourist information desk, situated in the town's central library on Regent Circus, sells a wide range of Magic Roundabout memorabilia that runs the range from keyrings to mugs to tea-towels and even t-shirts. So, if you've braved this colossal contraption of a road system you can celebrate your feat of derring-do with a suitable souvenir or two.

Whether you love it, hate it or are indifferent to it one thing is for sure: visit Swindon and you can't ignore it.

Happily for Swindon, this iconic, traffic-munching monster isn't the only magical thing about the town. I've already covered some of the public art and architecture. In the next chapter we'll take a look at the C word. Well, in this instance, sounding like a bra size, a double C: creativity and culture, both of which are plentiful, exceptional and magical.

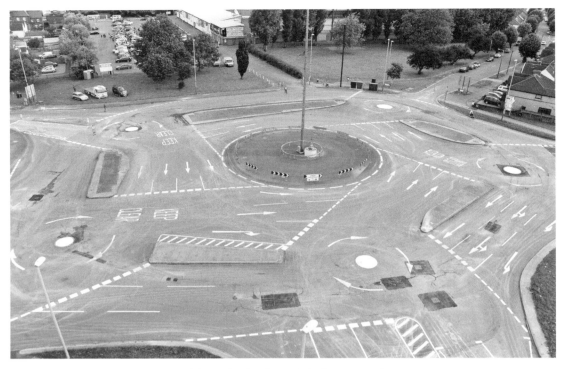

Aerial shot of the Magic Roundabout. (Richard Wintle/Calyx Pictures)

DID YOU KNOW?
Swindon-grown band XTC effectively and poetically capture the dizzying assault
on the senses this behemoth can induce in their 1981 song: 'English Roundabout':

> All the horns go 'beep! beep!
> All the people follow like sheep,
> I'm full of light and sound,
> Making my head go round, round.

Or at least that's the theory...

8. Swindon: The Creative and Cultural Hotspot

'A Petri dish has more culture than Swindon.' You'll hear this accusation, and others in similar vein, hurled at Swindon with monotonous and wearisome regularity and I've never understood why. Yes I know, Swindon has neither Shakespeare at the Tobacco Factory (Bristol) nor a theatre on the lines of Bristol Old Vic. Yet the suggestion that there is *nothing* of cultural interest in Swindon is risable. The fact is that, from the early days of the Mechanics' Institution, Swindonians have pursued an interest in the arts, as the programmes you see in the images below will testify. One is for the 1888 Grand Performance of Mendelssohn's Oratoria 'Elijah' staged at the New Swindon Mechanics' Institution and the other for Mlada at the Empire Theatre in 1947.

Music, and notably opera, was more than a bit player in Swindon's cultural past. The local collection in the central library has in its possession the most fabulous scrapbook. This thing of pure joy is a wonderful record of the performances of Swindon

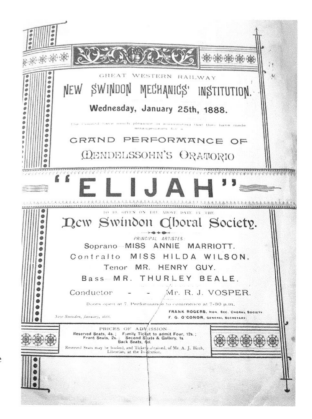

'Elijah' programme from a performance
by Swindon Musical Society.
(Reproduced with permission from
Local Studies, Swindon Libraries)

THE EMPIRE THEATRE - - SWINDON

Week Commencing Monday, March 17th, 1947
at 7.0 p.m.

OPERA-BALLET

MLADA

(RIMSKY-KORSAKOV)

by the

Swindon Musical Society

President: HIS WORSHIP THE MAYOR.

Musical Director: H. S. FAIRCLOUGH

Hon. Treasurer: B. L. MONAHAN,
Hon. Organising Sec.: EDITH A. WARD.
Hon. Secretary: THOS. S. MERRICK.

Page one

Mlada programme, Empire Theatre, 1947. (Reproduced with permission from Local Studies, Swindon Libraries)

Musical Society, which were, by any standards, a cut-above. Their regular material was Rimsky-Korsakov and Borodin – no lightweight subject matter for this group. Amateurs they may have been but amateurish they were not, as the cutting from a March 1947 edition of *The Times* shows: 'On the face of it there is little connexion between railway engines and Russian opera, but to those in the know Swindon is the place to look.'

Yet, never mind what there used to be in Swindon, let's focus on what there is now. In short: plenty. However, I have a word count demand so I'd better expand. Pablo Pcasso famously observed that the purpose of art is to wash the dust of daily life from our souls. With that in mind and stretching the analogy to cover the arts in general, there's no excuse to have anything less than a squeaky-clean soul in Swindon. It's impossible to give expansive mention to all aspects of Swindon's arts scene and all its artists, so instead I'll highlight a few of the many to illustrate my point: a cultural desert Swindon is not.

Aside from the Wyvern Theatre and the Arts Centre, there are several smaller theatre companies, both professional and amateur. One of them, the Western Players, began life as the Great Western Railway (Swindon) Mechanics Institution Amateur Theatre Society in the early 1900s, though there's research to suggest the group's history stretches back as far back as 1854. Not quite as old but longstanding even so are the Phoenix Players. Predating me (a few things do), they started life in 1954 as the Poetry Circle Players. It seems that, in 1946, when Swindon's first Arts Centre opened, one of the public library ancillary societies was the Poetry Circle. They met at the Arts Centre to read and discuss poetry and plays. Several clear examples of culture not happening in Swindon there then.

OPERA AT SWINDON

"MLADA"

THE TIMES 19-3-47
FROM OUR MUSIC CRITIC

SWINDON, MARCH 18

On the face of it there is little connexion between railway engines and Russian opera, but to those in the know Swindon is the place to look for both.

The Musical Society, which before this last war had performed half a dozen operas by Rimsky-Korsakov and Borodin, has wasted no time in renewing its unusual and valuable activities. Yesterday it gave the first of six performances of Rimsky-Korsakov's ballet-opera *Mlada*, no longer in its old home at the Institute but on the large stage of the Empire Theatre.

The combination of ballet with opera would deter most amateurs, but it is a stimulus to Mr. H. S. Fairclough, who looks after the musical education of Swindon and is the prime mover in these productions. Out of an adult class in music he has built a full symphony orchestra, a chorus, and finally a ballet class, and from their ranks he has found the soloists to sustain the principal roles.

The Swindon production was most workmanlike and creditable. The solo music, which is the most exacting test of amateur opera, was more than adequately sustained by Miss Eileen Tatnell and Mr. Raymond Hatherall, as Prince and Princess, both of whom put their words across. Some of the orchestral music would have taken a higher polish and the elaborate scenic production was not quite smooth on a first night. The dances devised by Mr. Jak Carter were all on the right lines, though his invention was a little strained by the sheer quantity and variety of ballet required, but again their performance was creditable. The important thing is that this very ambitious undertaking contained no lapses from taste or capability, and that such inequalities as must occur in amateur organizations were no impediment whatever to the full realization of the essential quality of what is an earlier and larger *Coq d'Or*.

Times cutting. (Reproduced with permission from Local Studies, Swindon Libraries)

Multimedia and Multicultural

An important aspect of Swindon's cultural landscape is Swindon Viewpoint, Britain's first and longest-running public access television service. Viewpoint began life in 1973 as a community cable TV channel. Today, Viewpoint is gathering and digitising early films to add to the largest collection of films of local life in the country.

Meanwhile, doing their bit for cultural harmony and the arts is the South Asian Performing Arts Centre (SAPAC). Formed in 2009, SAPAC brought together four large ethnic groups to promote music and dance from their regions. Their centre is open to anyone in Swindon and Wiltshire regardless of age or ethnicity. SAPAC often collaborate with Swindon Dance – a glittering gem in Swindon's cultural jewellery box. For over three decades, Swindon Dance has led innovation in UK dance development. The organization is one of only three places outside London providing the Diploma in Dance Teaching and Learning for Children and Young People (DDTAL) as one of the first registered centres and training providers for Trinity College London. They're also, among a whole host of other things, one of five UK centres working in partnership with the Royal Ballet School.

Studio at Swindon Dance, located in the Town Hall on Regent Circus.

Artistic Swindon

Swindon boasts more artists than you can shake a palette at. A huge number of artists live and work here, often using the town as their subject matter. I'll name but three of the many at this point: Caroline Day, Susan Carr and Terry Humphries.

In Plein Sight: Made in Swindon and Born-Again Swindonian Artists and an Artist's Collective

Susan Carr and Terry Humphries are both 'Plein Air' artists – 'En plein air' being a French expression meaning 'in the open air'. They've both painted countless scenes of the town, including Town Gardens and the Richard Jefferies Museum. A born Swindonian, Caroline Day also produces wide-ranging work often with Town Gardens as its subject. Those talented artists aside, the subject of Swindon as creative and cultural hotspot must give mention to two entities and three further artists – all connected in more ways than one as will become clear. Two of them, like me, are born-again Swindonians while the other is a born and bred Swindonian.

The Artsite Collective

Somehat unsung and unnoticed by many is Artsite and the Post Modern. The stencil artwork (owned by me) that you see in the image below is by Artiste artist Martin King. I assume irony was its intention. That or a nod to the 'Two Minutes' Hate in George Orwell's novel *1984*. Whichever it is, the irony is that Artsite is one of many Swindon things that ought to

be an un-ironic Swindon Borough Council site of rapturous applause. From the early years of Swindon Art College up until the 1980s Swindon had an active community arts scene. Artists such as Ken White and Carleton Attwood had studios in the town hall and there were a great many spaces around where artists could exhibit their work. That's much less the case now so all the more reason to appreciate Artsite.

Established at the turn of the millennium, Artsite is a self-funding, artist-led community located in Theatre Square, right by the Museum of Computing – yes, we have one of those too. Artsite then is a place where artists can find low-rent, twenty-four-hour studio space away from their domestic environment in which to develop their art. The proviso is that, in order to take advantage of the space on offer, the artists have to agree to input into the organisation.

Artsite newspaper article.

The people at Artsite understand each other's strengths and weaknesses and offer mutual support. Their ethos is that of the collective not the individual, all of which is brilliant in and of itself. Yet it's about so much more than that. All Artsite members support the community into developing their own creativity via all manner of workshops and activities. Whether for children, adults or those with mental health issues, the Artsite collective use their own creativity to develop creativity in others. Now isn't that something to applaud?

Photo of Swindon Borough Council applause. Artwork created by Martin King.

Swindon Open Studios

Yet another thing to applaud in Swindon's arts world is Swindon Open Studios. The whole open studios concept is now well known in many towns and districts, though this was not the case in 2003 when Swindon's first open studios took place. Originally organised by the local council, nowadays a committee of passionate volunteers make it happen. Across two weekends in September, to give flexibility to visitors, the event is an established fixture on Swindon's cultural scene.

Set of Swindon Open Studios brochures from recent years.

The great achievement of Swindon Open Studios is that it publicises the wide range of talented artists in Swindon and its environs and gives people access to them and to their work. Besides that though it fosters an artistic community that can share skills and feel encouraged and supported.

David Bent Hon CRAeS: The More You Look the More You See

Hidden motifs and stories are everywhere in David's work – though at all times it's accessible.

From modest beginnings displaying in a tent on a far edge of Fairford airfield, this born-again Swindonian's work in the aviation sector now flies high. So much so that David is credited with leading a new movement in modern aviation art. A combination of talent, teamwork, hard work and luck led David to achieve success in this 'air and art field'.

From Local and Global: From the Ground to the Sky

David's aviation art might be the strand he's most famous for but there are far more bristles to his brush than that. His body of work is diverse to say the least. David is well travelled and much of his work reflects his travel experiences. His love of nature is also clear in many of his art works, including his Landscape Geometry works. In 2017 Swindon Museum and Art Gallery acquired *Beach House West of Looe*, a key piece from this particular range of David's work.

Beach House West of Looe. (Copyright David Bent)

David Bent at work in his Swindon studio painting the Red Arrows flying through the Bluebell Woods.

Social issues make their way onto David's canvas too in the form of response work. His Movement 2000 collection is a set of eight powerful and haunting paintings depicting the movement of people around the world, displaced through no fault of their own.

DID YOU KNOW?

In 2012/2013 the RAF Museum hosted 'Fresh Air', a year-long retrospective of David's work – the first of its kind for a living artist. The exhibition inspired 800 children to create their own artworks, displayed under the wings of a Mosquito aeroplane. Other exhibitions include the launch of Tribute 100 at the National Memorial Arboretum, marking the 100th anniversary of the Royal Air Force in 2018 and in the Crypt in St Paul's Cathedral.

Supporters of David's work include the Red Arrows, who first invited him to collaborate as artist in residence in 2007. A celebratory book collaboration between David, the Red Arrows and Breitling was presented by Red 1 to HRH Prince Charles at RIAT 2014.

David is the first artist in thirty years to receive Honorary Companionship of the Royal Aeronautical Society.

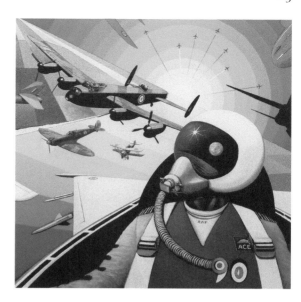

Option 7. (Copyright David Bent)

This collection is a notable example that remains as relevant today as when he painted it. There's even early 1980s computer graphics among his output from the days when David had a small but pioneering computer graphics company called Spectre Graphics.

David supports and participates in many positive local initiatives, including exhibiting at The Great Western Hospital, at Radnor Street chapel as part of Swindon's Battle of Britain 75th anniversary commemorations and supporting Open Studios for over 14 years.

Tim Carroll: Figuratively Speaking

Recently using Swindon as his subject matter, Tim Carroll is a long-standing born-again Swindonian. The schoolboy Tim arrived here in 1969 and attended St Joseph's Comprehensive. Later acquiring a BA in fine art, Tim is now a member of Bath's Society of Artists and exhibits often at the Royal West of England Academy in Bristol. Typical of Tim's output is large-scale figurative work along with small ceramic sculptures fired in his kiln at home. I own a piece of Tim's work bought in Artiste before I knew him personally. It features four figures interlinked forming a square. I like to think of them as synchronised swimmers. This motif features a lot in Tim's work: in paintings and ceramics as well as in the form I have.

In recent years Tim has busied himself on a number of local art projects aside from his restoration of the *Blondinis*. They include stoneware ceramic insect plaques on a cycle track at Cotswold Country Park and a range of exhibitions and projects in collaboration with Artsite, one of which is the mural in Queen's Park. It used children's drawings of the park as the design's basis, all painted by fellow Artsite members. Tim also recorded, via sketch work, the installation of the light sculpture (created by Icelandic artist Gudrun Haraldsdottir) on the wall of the Wyvern Theatre.

My Tim Carroll piece.

One Hundred Views of Swindon
Tim's most recent large project is his fabulous *One Hundred Views of Swindon. (capital V)* He started this series of paintings in 2014 and finished them in 2017. All the same size, 25 cm x 30 cm, Tim produced them by making a drawing 'sur le motif' (translated as 'on the spot'), before transferring the drawing to board and then painting it in the studio. As great as it would be to own all 100 of these paintings that's hardly practical, so having them all collected together in the gorgeous *One Hundred Views of Swindon* book is rather wonderful.

Front cover of Tim Carroll's *One Hundred Views of Swindon.*

Ken White: Painter not Artist

That's his description of himself not mine. He's emphatic on the point. Yet, however you describe him, his talent is indisputable.

A born Swindonian, Ken had the good fortune to get what you'd call 'a big break'. First though, like so many young men in Swindon, the tender age of fifteen saw him enter the Works (the third generation of his family to go 'inside') as a rivet-hotter. Escaping that role, he began his artistic career with sign-writing and stenciling numbers on carriages in the Works. During this period Ken went to evening classes at Swindon Art College to study O- and A-Level art with the intention of becoming a full-time artist. Leaving the railway workshops in 1962, Ken enrolled in a full-time, four-year-long diploma course at Swindon Art College with a vision of becoming a full-time artist. A vision that came to fruition as a muralist and leading exponent of Trompe l'oeil with over 100 murals painted worldwide.

While David Bent was a late pop-up on my horizon, Ken White had been there for a long time. Why? Because Ken White found fame and a lucrative living as a muralist. Swindon used to have dozens of his murals, painted in the 1970s and 1980s, around the town and across the borough – sad to say all but one are gone now. Though, if you were ever a *SHE* magazine reader, you may well have bought this issue with a free template designed by Ken for you to create your own 'muriel' in your home, in true Hilda Ogden (*Coronation Street*) style.

SHE magazine mural template.

Ken Gets a Big Break

So what of Ken's big break? In 1977, Ken's Golden Lion Bridge mural found its way into the national press when the pharmaceutical, paint and chemical company Bayer used the mural in a large-scale advertising campaign. Bayer's advertisement proved to be pivotal for Ken leading, as it did, to getting one Richard Branson to sit up and take notice. The Golden Lion mural is the first of Ken's Swindon murals and the only one to survive.

Golden Lion Bridge mural by Ken White.

One of Richard Branson's staff saw it and brought it to the boss' attention. Mr Branson had, at the time, engaged a different artist who'd made a poor job. The upshot of it all was that Branson put Ken on a retainer, a relationship that would last for twenty-six years and gave Ken and his family financial security and Ken the opportunity to do other work. No starving in a Swindon garret for this artist. Extraordinary! During this time Ken travelled the world painting murals in Branson's airport lounges, record shops and more.

It's not been all murals and Trompe l'oeil though. Music album covers have featured in his work too. In 1980, home-grown new-wave band XTC released *Black Sea*, their fourth studio album. Ken painted the sky and seascape backdrop for the cover. Andy Partridge sketched out the design of a flying seagull, a ship's mast and a waning moon that together spelled out the band's name. Ken did the rest.

Nowadays Ken focuses his work on paintings of life in and around the Works but in the Swindon of the 1940s and 1950s. A typical example being *Uphill* – albeit this is a linocut rather than a painting.

Left: XTC album cover painted by Ken White with Andy Partridge's design.

An example of Ken White's modern work *Uphill*.

Above: The Scarlet Lady emblem on Virgin aircraft.

DID YOU KNOW?

In 1982, Ken White painted a mural, commissioned by Jacob Rothschild, christened as one of the most spectacular ever painted in London. It featured two full-sized classical eighteenth-century façades on the Royal Opera House, overlooking the Jubilee Gardens Piazza in Covent Garden.

While all but one of his Swindon murals are gone there may still be some around in the rest of Europe and North America.

For many years Ken worked as the personal artist for Virgin boss Richard Branson. He completed works for him in many Virgin establishments throughout the world, including record shops, hotels and airport lounges. As a result of that relationship you'll know at least one iconic piece of Ken White's work.

Two years after Branson's 1984 launch of Virgin Atlantic, Ken designed and painted the scantily clad Scarlet Lady emblem. Ken based his design on the Second World War pilots' girlie images with which they adorned their planes, mashed up with the work of Peruvian pin-up artist Alberto Vargas – a contributor to *Playboy* magazine. Ken did the design work in his Swindon studio and sent the result to Boeing's American works. There they reproduced it on to a 20-foot-long transfer and heat sealed it on to the aeroplane's fuselage.

Where the RIAT (Royal International Air Tattoo) helped David Bent's career get airborne then Richard Branson literally gave wings to Ken White's.

This picture from a 1979 edition of *The Telegraph* shows Ken White and David Bent in London with their respective mural work.

In a superb slice of life and artistic symmetry, there was a time, way back in the 1970s, when (unbeknown to each other) both David Bent and Ken White worked as muralists in London, David as part of his tenure as a youth worker specialising in art project work – painting a huge skateboarding mural, and Ken working on his commissions for Richard Branson. Now here they are, living and working in the same town. It's a small world. One full of big murals and pots and pots of paint.

Swindon Museum and Art Gallery (SMAG)

DID YOU KNOW?
Swindon is a town in possession of a rather fine collection of modern British art. The collection began in 1946 when local businessman H. J. P. Bomford offered twenty-one paintings and drawings that included works by Ben Nicholson, Graham Sutherland and L. S. Lowry.

Today the collection comprises around 600 works of art and 300 studio ceramics made between 1880 and 2017, all from artists who lived and worked in Britain. There is also a small collection of modern sculpture by artists including Michael Craig-Martin, H. Carleton Attwood, Roger Leigh and Stephen Tomlin.

This wonderful art collection, along with massive local history and archaeological collections, is currently housed in Apsley House in Old Swindon. I say currently because Swindon needs and deserves a new home for its outstanding art, archaeology and local collections. Apsley House is delightful but unfit for purpose in the twenty-first century. It's my fervent hope that a solution presents itself.

SMAG is active in staging family activities and partnerships with schools and collections. The curator delivers free lunchtime talks on a regular basis. These tend to be centred around whatever the current exhibition is. SMAG's membership support group,

Apsley House, current home of Swindon Museum and Art Gallery. (Photo by Chris Eley)

the friends of SMAG, organise a range of talks, trips and events to raise funds and to create engagement with the museum's exhibitions and exhibitors. Yet more culture not happening in Swindon.

Literary Pursuits
Art not your thing? Fret not, Swindon caters to an interest in the literary too. Two standout events on Swindon's cultural calendar are the most marvellous festival of literature and Swindon's poetry festival. 2018 marks the silver anniversary of Swindon's Festival of Literature. A firm fixture on Wiltshire's cultural calendar, the festival is loved by locals and held in high national regard. Thanks to the hard work and dedication of festival director Matt Holland and funding from Arts Council England, hand in hand with a range of Swindon supporters and sponsors and partners, literature-related activities thrive in Swindon.

Poet's Corner
Poetry Swindon started life in 2008 with a group of poets keen to help poetry thrive here. Their mission is poetic in its simplicity: to encourage an appreciation of poetry. The group achieves this with all manner of publications, workshops and events – including the poetry festival – for adults, children and families.

Beat Out that Rhythm on a Drum
Nor is music non-existent in Swindon. Where once Swindon's backing track was the GWR hooter and the thud, thud, thud of the steam hammer now there is jazz and jive, the Ministry of Samba, the Reggae Garden and Swindon Symphony Orchestra. The town even boasts a chamber music recital series with Dame Evelyn Glennie as its patron. This is far from all there is musically in Swindon; what's mentioned here is a mere quaver on Swindon's musical scales. Swindon then, far from being a cultural desert, is in fact a lush and verdant oasis.

In Conclusion
Swindon's official motto is '*SALUBRITAS ET INDUSTRIA*'. This tends to be translated as 'Health and Industry' with Industry taken as a mass noun. It's important to remember, though, when this motto was conceived, New Swindon had only one industry: the railway, built on hard work. It's my belief then that hard work, or industriousness, is the sense to take from *Industria.*

Swindon's motto then is a fine one. Yet, with tongue firmly in cheek I offer you an alternative. Laden with affection for a town that's been good to me and which I've grown to love, I give you: '*Malum enim non cogitant Swindon*, which roughly translates to: 'Swindon: It's not as bad as you think.'

It's my ardent hope that the pages of this book demonstrate that not only is Swindon not as bad as you think it's actually *much better* than you think! Because, as with David Bent's artistry, when it comes to Swindon, the more you look the more you see.

This plaque commemorates the formal opening of
the final stage of the Brunel Centre and its naming in honour of
David Murray John, OBE, BA,
Town Clerk of the Borough of Swindon
from 1938 to 1974 and Freeman of the Borough.

The Council of the Borough of Thamesdown
thus records the gratitude of the people of Swindon
to one who made an invaluable contribution towards
the expansion and redevelopment of the town.

Nineteenth day of November 1976

Councillor L Gowing
Mayor

David M Kent, BA
Chief Executive
and Town Clerk

SALUBRITAS ET INDUSTRIA

Swindon's coat of arms and motto.

Bibliography

Carter, G. et al., *Swindon Heritage* magazine
Chandler, J., *Swindon Decoded*
Darwin, B., *A Century of Medical Service*
Jefferies, R., *The Story of Swindon*
Pringle, M., *Swindon: Remembering 1914–1918*

http://eprints.hud.ac.uk/id/eprint/14051/1/415.pdf

Acknowledgements

I extend my thanks to everyone that I've dispatched to take photos, that have sent me photos and those who have taken the time to send me information that I've used to furnish the pages of this book. You know who are – thank you.

A special note of thanks goes to the local studies team at Swindon Central Library. The local and family history collection curated and cared for the local studies team has a reputation for being one of the best of its kind in the country. It's a veritable treasure trove and a gift to a non-fiction paperback writer.

That aside, every attempt has been made to seek permission for copyright material used in this book. However, if I have inadvertently used copyright material without permission/acknowledgement I apologise and will make the necessary correction at the first opportunity.